LEGENDARY LO

OF

CENTER CITY
PHILADELPHIA

PENNSYLVANIA

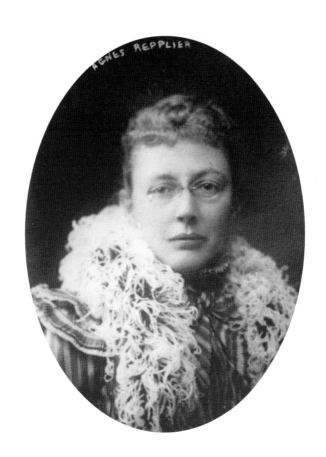

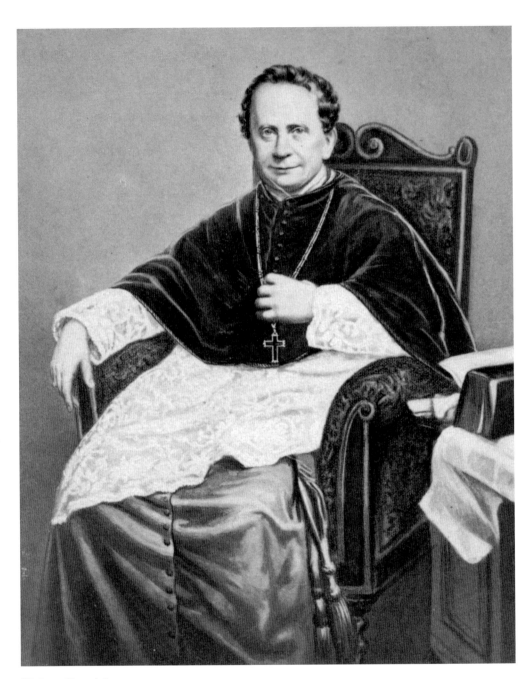

Bishop Kenrick
See page 117. (Courtesy of Marita Krivda Poxon.)

Page 1: Agnes Repplier
See page 28. (Courtesy of Vintage Reprints.)

LEGENDARY LOCALS
——— OF ———

CENTER CITY PHILADELPHIA

PENNSYLVANIA

THOM NICKELS

LEGENDARY
LOCALS.

Legendary Locals is an imprint of Arcadia Publishing
Charleston, South Carolina

Printed in the United States of America

Library of Congress Control Number: 2013952587

For all general information, please contact Arcadia Publishing:
Telephone 843-853-2070
Fax 843-853-0044
E-mail sales@arcadiapublishing.com
For customer service and orders:
Toll-Free 1-888-313-2665

Visit us on the Internet at www.arcadiapublishing.com

Dedication

To Agnes Repplier, once called the Dean of US Essayists, whose career as an essayist spanned two distinctly different eras in American life and literature; from her brief friendship with Walt Whitman (whose paper-cluttered house she pronounced a fire hazard), to her association with Henry James and Edith Wharton, to her world travels, lectures, and books, she was and still is a Philadelphia treasure despite her belief that the city was indifferent to those who tried to lift it to prominence.

On the Front Cover: Clockwise from top left:
Noel G. Miles, painter (Courtesy of Jim Talone, see page 35); George Lippard, writer (Courtesy of the Library Company of Philadelphia, see pages 11 and 16); Mario Lanza, singer (Courtesy of the Mario Lanza Museum, see page 101); Pearl S. Buck, author (Courtesy of the Pearl Buck Foundation, see page 55); Sara Garonzik, producer and director (Courtesy of Jim Talone, see page 47); Rembrandt Peale, painter (Courtesy of the Library Company of Philadelphia, see page 13); William Penn, founder of the Province of Pennsylvania (Courtesy of Jim Talone, see page 6), George Meade, Union general (Courtesy of the Library Company of Philadelphia, see page 17), Blanka Zizka, cofounder of The Wilma Project (Courtesy of the Wilma Theater, see page 63).

On the Back Cover: From left to right:
Robert and Claudia Christian, founders of *University City Review* and *Weekly Press* (Courtesy of Jim Talone, see page 83); Fr. Mark Shinn, archpriest and pastor of St. Andrew's Russian Orthodox Cathedral (Courtesy of Jim Talone, see pages 114 and 115).

CONTENTS

ACKNOWLEDGMENTS

A special thank-you goes to Bryn Mawr photographer Jim Talone for his expertise, "camera eye," and knack for navigating dense Center City traffic while traveling to various photo shoots. Talone's aim for perfection rarely fails to disappoint.

William Penn

William Penn was born in England on October 14, 1644. He had been expelled from Oxford University and imprisoned several times for radical preaching after his conversion from the Church of England to Quakerism. However, Penn also lived the privileged life of the landed gentry, managing his father's estates in Ireland. He first arrived in the new colonies in 1682, founding the colony he named after his deceased father and drawing up plans for his "Greene Country Towne," or Philadelphia. Penn traveled to many countries, including France and Russia. He became well acquainted with Czar Peter the Great, causing the Czar to exhibit an avid interest in Quakerism. Although born into an autocratic family, he mingled and associated with all people, regardless of class. The founder of Pennsylvania and Philadelphia also held slaves but released them a full 190 years before the start of the Civil War. He died on July 30, 1718, in England, after a period of inactivity, although his days were spent attending religious services. "A great concourse attended his funeral, and a noble and affecting testimony was borne to his honored life," wrote George Edward Ellis in *William Penn.* (Courtesy of Jim Talone.)

INTRODUCTION

In her book *Philadelphia: The Place and the People* (1898), Agnes Repplier (to whom this book is dedicated) writes that, above all, "The Quaker City lacks that discriminating enthusiasm for her own children . . . which enables more zealous towns to rend the skies with shrill paeans of applause." Repplier goes on to say, "If mistaking geese for swans produces sad confusion . . . the mistaking of swans for geese may also be a serious error. The birds either languish or fly away to keener air." What Repplier had in mind were those Philadelphians who left the city for more welcoming environments.

Repplier's writing career lasted 65 years and attracted the admiration of both Henry James and Edith Wharton; yet, in order to experience the fullness of her reading public's appreciation, she had to travel to Boston. Her biographer, George Stewart Stokes, states the following:

> If her head had been understandably turned by Boston, it was swiftly unturned again by Philadelphia. Back home, she was merely Agnes Repplier, a relatively insignificant writer living quietly west of the Schuylkill. Here she found no open-arms reception and this in spite of her 'triumph' at Boston. Here she found only obscurity, the obscurity, she felt, that is Philadelphia itself.

In *The Perennial Philadelphians* (1963), Nathaniel Burt lays the blame for the city's failure to be driven by literature on the effects of colonialism. "Philadelphians were slobbering over Tennyson and Thackeray," he writes, "while they condescended to Emerson and Hawthorne." While Repplier may have admired Thackeray, she had no compulsions against sharing a drink of whiskey (in a china toothbrush mug) with Walt Whitman even as most Philadelphians, according to Burt, considered Whitman and Herman Melville "rude barbarians." Burt concludes, "In later years, colonialism became provincialism, and Philadelphians waited for the accolade from Boston or New York."

In his book *Memories and Portraits, Explorations in American Thought*, Philadelphia philosopher H.G. Callaway writes of "the Philadelphia jinx":

> The recurrent hope is that the cultural reserve of Philadelphia . . . may yet produce something of value out of the deep historical significance of the place. . . . But this is not typically how things turn out. Instead a preeminent tendency is to uncritically follow trends from afar or else to follow uncritically some local and provincial notion.

That provincial notion, of course, is what caused another historian, John Lukacs, to write in 1980 that "so often has Philadelphia favored the second—if not the third-rate, due to a sort of provincial suspicion well hidden behind a successfully maintained pose of patrician reserve."

Consider Charles Dickens's impression of Philadelphia after his visit here in 1840: "Treating of its general characteristics, I should be disposed to say that it is more provincial than Boston or New York." More provincial, did he say? That's shocking, although I can attest to that because when I left the city for Boston when I turned 20, I found the City of the Puritans to be an emboldened version of the town I had just left. Dickens believed that Philadelphia's character could be attributed to the high numbers of native inhabitants.

Many people have asked: *What* constitutes a *legendary* Philadelphian?

An activist famous for his work to save a historic city landmark told me that he was not notable enough to be listed alongside a Louis Kahn or Eugene Ormandy. "You're being much too humble," I protested. "Your place is right here." Then, in a second bow-out of dubious humility, a writer long noted for her celebrity interviews insisted that her only desire in life was to fade away into that good night, into her

retirement and obscurity—despite the fact that she still publishes regularly. Both the activist and the writer, I think, illustrate Repplier's swans mistaking themselves as geese while they also happen to fall into Callaway's category of Philadelphians who follow "uncritically some local and provincial notion" (or what it means to be a "notable").

False humility might be said to be as serious a "crime" as a narcissistic tendency to think of oneself as a god.

Of the many books written about Philadelphia, namely *Philadelphia Then and Now* by Edward Arthur Mauger; *Old Philadelphia in Early Photographs 1839–1914* by Robert Looney, and the 1982 book *Philadelphia, A 300 Year History* by Russell Weigley, Weigley's stands out if only because I was pleased to find a reference to my grandfather, Frank V. Nickels (1891–1985), a Philadelphia architect who designed schools, auditoriums, convents, churches, rectories, and private dwellings, such as 1521 Spruce Street, the Frances Plaza Apartments at Lombard and Twentieth Street, the Germantown home of Alfred R. Smith, and Nazareth Hospital for the Sisters of the Holy Family of Nazareth in Northeast Philadelphia. He did much of his work for the Archdiocese of Philadelphia. Nickels designed his own home at 40 Albemarle Avenue in Lansdowne, Pennsylvania. A collection of his blueprints can be found at the Athenaeum on Washington Square. A lover of classical music and art, he was married to the former Pauline Clavey, an opera singer from the city of Wilmington.

Another notable, Edna Rose Ritchings (or Mother Divine), was the white Canadian wife of Philadelphia legend Father Divine, founder of the Peace Mission Movement. They met in 1946.

In my work as a journalist, I visited Mother Divine's residence, Woodmont, a 72-acre estate that continues to be the home base of the Peace Mission Movement, started by Father Divine in 1919.

The mansion itself is a multiroom French Gothic masterpiece, designed in 1892 by Quaker architect William Price for Philadelphia industrialist Alan J, Wood Jr. After the demise of the Gilded Age and the selling off of many of Philadelphia's old mansions, Woodmont was sold to Father Divine for $75,000.

While visiting Woodmont, I watched as Mother Divine descended a long grand staircase dressed in a long beaded white dress while being escorted by an elderly woman in a beret. It was a cinematic moment with Royal Family elements.

The highpoint of my visit was the banquet, or the Peace Mission's version of a Holy Communion service. Imagine a table that seats about 60 people and a porcelain swan on a "lake" of glass as the centerpiece with Mother at the head. Beside her is an empty chair and place setting in remembrance of Father Divine.

How can you do a Philly-notable book without mentioning Grace Kelly? My Aunt Dorothy in the 1960s loved the fact that Princess Grace, a Catholic from Philadelphia, seemed to be getting more press than the Queen of England, a Protestant, despite the fact that English royalty thought of Monaco royalty as second rate, "thrift store royalty."

When traveling with Dorothy in her cream-colored Chevrolet Impala, she'd drive up to the Kelly home in East Falls, practically slam on the brakes, and exclaim, "There's where Grace grew up! Her father was a common brick layer!" Together we'd examine the grounds of the house as if hunting for tell-tale signs: a lock of Kelly's hair or a mash note from Alfred Hitchcock on the lawn. Aunt Dorothy's penchant for the living legend came to a head when the princess herself appeared at a special High Mass at the Cathedral of Saints Peter and Paul, and happened to be standing near the cathedral doors. Aunt Dorothy, situated nearby, extended her gloved hand to the Monaco icon, apparently touching a portion of the princess's tweed jacket. Her well-meaning "Hello, dear Princess" was greeted with a cold Medusa stare. "I gathered from that," Aunt Dorothy reminded me years later, "that it is not permissible to touch royalty—ever!" Even, of course, royalty of the thrift store kind.

Of course, Philadelphia has more notables than can possibly be contained within 128 pages. The question—Who to include and who not to include—has not always been easy to answer.

Rummaging through an old 1960s edition of the *Philadelphia Inquirer*, I wanted to include the story of society editor Ruth Seltzer, who chronicled the daily doings of the city's Social Register set. One Seltzer column contains a photograph of a Miss Emily Bache of Center City, dressed to the nines in pearls and wearing a hat that would rival any worn by the Queen of England. Bache is shown enjoying a steak dinner

at the Athenaeum. The caption states that she's not only an Athenaeum shareholder but also the great-great-great granddaughter of Benjamin Franklin. As much as I wanted to include Emily Bache, information about the woman could not be found. Like so many others, she had been erased from history.

Philadelphia is also known as "Poetdelphia" because there seems to be a poet on every street corner. There are city-based poetry magazines like the *American Poetry Review*, the *Philadelphia Poets Journal* and the *New Purlieu Review*. Every year in April, Larry Robin of Moonstone hosts Poetry Link, in which hundreds of poets sign up for an opportunity to read their work on stage for four minutes. Poetry Link is an all-day event. It is a chance for the city's poets to network. The huge range of poets in the city includes women poets who come to Moonstone dressed like Emily Dickinson; "come to Jesus" poets who list the things that Jesus has done for them lately; girlfriend-boyfriend poets who write about their love for one another; female poets (dressed in black) who write about how they got even with cruel ex-boyfriends; spurned boyfriend poets who write about "Medusa ex-girlfriends." There are jazz poets who try to sound like Ella Fitzgerald; slam poets who combine their words with body spasms; retro, San Francisco–style, goatee-sporting beat poets who scream louder than they should as the cocked fedora on their head falls to the floor. There are poets who take 15 minutes to explain the poem they are about to read, or who take 25 minutes to read a series of poems after promising to be brief.

In many ways, working on this book reminded me of another list: Philadelphia's Walk of Fame. In 1987, the Philadelphia Music Alliance created a Walk of Fame along South Broad Street, or the Avenue of the Arts. The idea was to install commemorative sidewalk bronze plaques with the names of famous-born Philadelphians who made it big in the music world—jazz, classical, gospel, rock, R&B, and opera. Developed as a way to showcase the musical legacy of a great city, the Philadelphia Music Alliance, a community-based, not-for-profit organization founded in 1986, announced that among the first plaque inductees would be city greats like Marian Anderson, Mario Lanza, Dizzy Gillespie, Bessie Smith and Chubby Checker.

By the early 1990s, the new plaques on Broad Street were shiny and bright, and the accompanying inductee parties, photo ops, and gala dinners were given a prominent place in the news. Over the years, new names were added to the Walk of Fame, such as the 1996 addition of Joan Jett, who was present when her commemorative plaque was installed. In 1995, the Delfonics were photographed beside their plaque, as was talk show host and singer Mike Douglas in 1997.

The Philadelphia Music Alliance has an archival record of the parties and sidewalk events, including photographs of many of the 100-plus inductees like Ethel Waters, Leopold Stokowski, Samuel Barber, Pearl Bailey, Dick Clark, and Fabian (a pompadour-sky-high teen heartthrob in the late 1950s and early 1960s).

While walking along Broad Street some time ago, I made it a point to study the condition of the plaques near the Academy of Music. Not only are quite a few of the plaques sunken into the sidewalk, but many are so dirty and eroded that it makes you wonder if anybody in Philadelphia even cares about these bronzes anymore. Gone are the parties, the galas, and the on-site photo ops with fans reeling behind police barricades. In fact, the only people who pay attention to the Walk of Fame seem to be passers by who glance at them while flicking occasional cigarette butts on random plaques like the one commemorating the Oak Ridge Boys.

In the 1990s, there were periodic "star dust" cleaning parties where music and radio celebrities would lend a hand scrubbing city grime off the various plaques. Events like this are no more, which seems to indicate that it has either become too expensive to maintain the plaques, or that there's been a real change in the way the normal citizen perceives celebrity.

Our age, after all, is the age of instantaneous celebrity when people expect to become famous for nothing at all. A musician working for decades may never achieve the star power of a silicone-lipped reality TV bit player who happens to catch the eye of a lascivious producer. Gone are the days when celebrity was more often than not viewed as something acquired through great effort, talent, and skill.

Legendary Locals of Philadelphia, hopefully, breaks this mold.

CHAPTER ONE

Early Pioneers of Politics, the Arts, and Science

George Lippard, a 19th-century journalist and novelist, was a friend of Edgar Allen Poe. For much of his writing life, he was as much an outlaw as artist Thomas Eakins, who shook the Philadelphia art establishment when he introduced nude modeling to the students at the Pennsylvania Academy of the Fine Arts. Eakins's banishment from teaching was not the only punishment he received: for decades, he lay in an unmarked grave. When writer/dandy Bayard Taylor became an established writer by 1865, he told everyone who would listen that he was a better scribe than Walt Whitman. Despite the grandstanding, the tables turned, and Taylor's work fell into obscurity while Whitman's soared. Decades before the birth of Eakins, Catholic bishop Francis Patrick Kenrick (1796–1863) believed that the Philadelphia cholera outbreak in 1832 was the result of God's judgment on the city for its overindulgence in food and drink. Abolitionist and early civil rights activist Octavius Valentine Cato had other ideas, viewing not food as the enemy, but enforced segregation. Cato became the nation's first "Rosa Parks" when he boarded a segregated Philadelphia trolley car.

Teedyuscung

In 1764, the final council of the Delaware Indians was held prior to the tribe's banishment to the Wyoming Valley. In 1756, the Quakers in Philadelphia had organized "the Friendly Association for regaining and preserving peace with the Indians." Teedyuscung was the last Lenni Lenape chief to leave the Delaware Valley. He was often accused of caring for the white man more than for his own people. Teedyuscung and other members of the tribe burned to death in their house after a drunken frolic. This sculpture by artist Massey Rhind was erected in 1902 in Valley Green, Fairmount Park, just outside Center City. (Courtesy of John Kiker.)

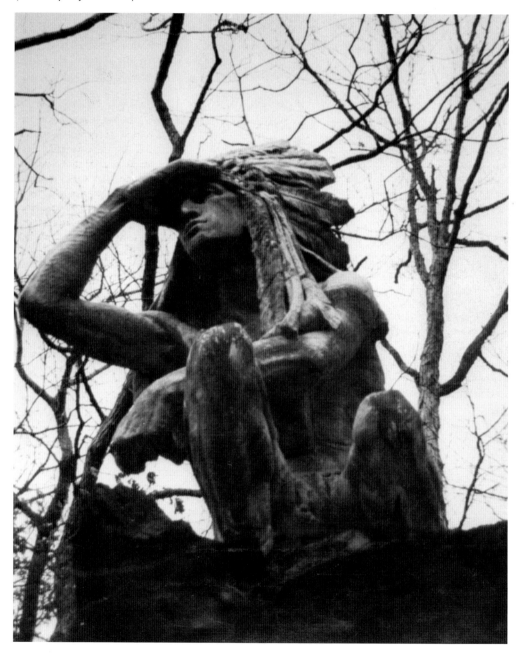

Rembrandt Peale

The son of Philadelphia painter Charles Willson Peale, Rembrandt Peale was born in Bucks County, Pennsylvania, on February 22, 1778, the same day as George Washington. Self-taught and hardworking, he painted his first self portrait at age 13 after studying his father's techniques and examining prints exhibited throughout the city. He met Washington in July 1787 when the president was attending the Constitutional Convention. At that time, Peale's father approached Washington for his son and arranged for three portrait sittings of three hours each. His portrait of Washington was so true to form that it was labeled "unidealized." Peale married Mary May Short and had nine children. Returning from England after studying with Benjamin West, he is said to have been disappointed at the reception he received in Philadelphia. However, unlike essayist Agnes Repplier, who experienced a similar indifference, he chose to not forget the slight but instead moved to Baltimore. A conscientious objector during the War of 1812, he left that city in 1814, just before the British siege. He returned to Philadelphia after some time in Boston but led a financially strapped life for over a decade while looking for work. At the time of his death in 1860, he had moved beyond portraiture and had perfected large-scale paintings. (Courtesy of the Library Company of Philadelphia.)

Walt Whitman

Walt Whitman, called "disgusting and vile" in his day, is now considered to be America's greatest and most influential poet. Although he was a newspaper editor and taught school for a time in Long Island, he moved to Camden, just across the river from Philadelphia, in 1873 and lived there until his death in 1892. Whitman's use of free verse established it as an accepted form of American poetry. Before his seminal work, *Leaves of Grass*, he held a series of newspaper editorships in which he had many personality conflicts and editorial clashes with higher-ups. Whitman's fame first grew in Europe, attracting the admiration of Oscar Wilde, who visited the poet in Camden. Essayist Agnes Repplier believed that Whitman was "an incurable poseur" and that he loved his indecency, "clinging to it with almost embarrassing ardor." (1854 engraving by Samuel Hollyer; courtesy New Jersey Division of Parks and Forestry.)

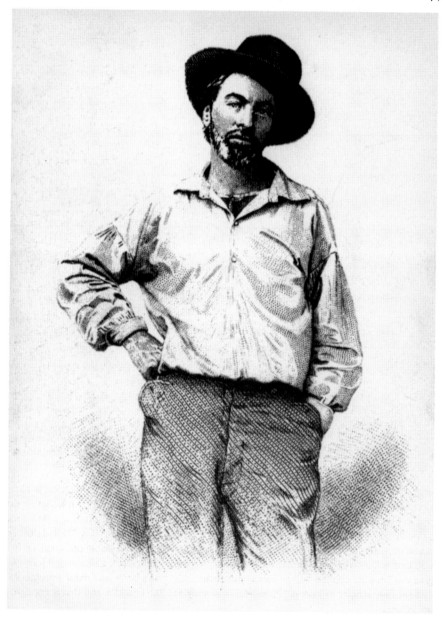

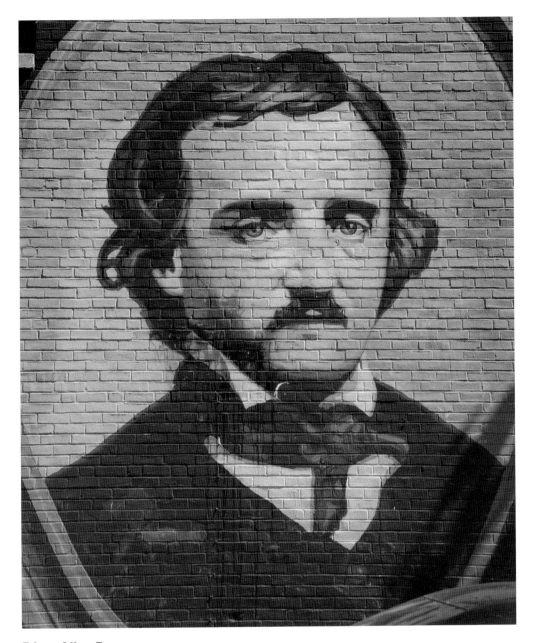

Edgar Allen Poe
Edgar Allen Poe spent six of his most creative years in Philadelphia. A poet, short story writer, novelist, and essayist, Poe lived at 532 North Seventh Street. When not writing, he could be found floating on a barge on Fairmont Park's Wissachickon Creek. In 2008, Poe scholar Edward Pettit told the *New York Times* that Poe's body belongs in Philadelphia, not the city of Baltimore, claiming that "Philadelphia's rampant crime and violence in the mid-19th century framed Poe's sinister outlook and inspired his creation of the detective fiction genre." In response, the curator of Baltimore's Poe House, Jeff Jerome, said, "Philadelphia can keep its broken bell and its cheese steak, but Poe's body isn't going anywhere." The *Times* quoted another scholar as saying, "Philadelphia already has Ben Franklin, and that is enough." (Courtesy of Jim Talone.)

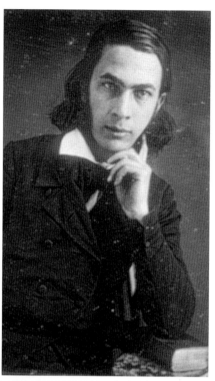

George Lippard

This popular, widely read American novelist was a major force in antebellum America. Born in 1822, his death in 1854 came well before the start of the Civil War although it is said that his writings on slavery awakened Abraham Lincoln to the plight of slaves. A friend of Edgar Allan Poe (some critics call him "far weirder than Poe"), he is noted for his Gothic sensational style and his interest in esoteric spirituality. His books include, *Monks of Monk Hall: A Romance of Philadelphia Life, Mystery, and Crime, Washington and His Generals,* and *Legends of Mexico.* In his preface to *Monks of Monk Hall,* Lippard wrote that it was his intention to write a book that "describes all the phases of a corrupt social system, as manifested in the City of Philadelphia." He also adds, "To the young man or young woman who may read this book when I am dead, I have a word to say: Would to God that the evils recorded in these pages, were not based upon facts. Would to God that the experience of my life had not impressed me so vividly with the colossal vices and the terrible deformities, presented in the social system of this Large City, in the Nineteenth Century." (Courtesy of the Library Company of Philadelphia.)

John Bartrum

Called by some the greatest botanist in the world, Bartrum (1699–1777) studied medicine and medicinal plants while traveling extensively through the early American colonies and collecting a variety of plants. His book *Diary of a Journey through the Carolinas, Georgia, and Florida* (1765–1766) attracted considerable attention. Bartrum was cofounder with Benjamin Franklin of the American Philosophical Society in 1743. His eight-acre botanic garden, Bartrum's Gardens, on the banks of the Schuylkill River was the first botanic collection in North America. (Author's collection.)

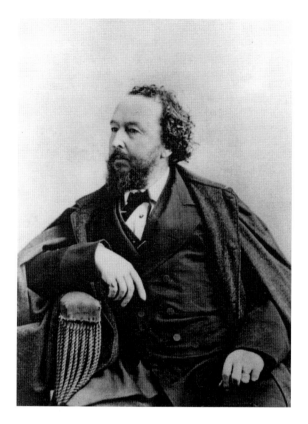

Bayard Taylor

Bayard Taylor was born on January 11, 1825, in suburban Philadelphia. After a trip to Europe in lieu of a university education, he published his first book of poems, followed by the publication of his travel essays in the *Saturday Evening Post*. Taylor's novel, *Joseph and His Friend*, was serialized in 1869 by the *Atlantic Monthly*. A contemporary of Walt Whitman's, Taylor competed with Whitman to write the 1879 National Centennial Hymn and was awarded the honor. Taylor often insisted that Whitman was a "third-rate poet attempting to gratify his restless passion for personal notoriety" and added that *Leaves of Grass* was not fit to "be read aloud under the evening lamp." Immensely prolific, at the time of his death on December 19, 1878, he had published some 50 books and had just been made ambassador to Germany. (Courtesy of Joseph A. Lordi and the Bayard Taylor Memorial Library.)

Gen. George Meade (1815–1872)

This talented civil engineer fought in the Second Seminole War and the Mexican-American War before his role as a Union general in the American Civil War, during which he defeated Confederate general Robert E. Lee at Gettysburg in 1863. Born in Spain (where his father was a visiting Philadelphia merchant), Meade's life after Gettysburg was considerably more sedate. He was a commissioner of Fairmount Park from 1866 to 1872. As a token of appreciation for Meade's war service, the City of Philadelphia gave the general's widow a house at 1836 Delancey Place. General Meade's great-grandson, George Meade Easby (1918–2005), was an author, actor, film producer, and antique collector. He lived in Chestnut Hill's Baleroy Mansion with his domestic partner, Robert Yrigoyen. (Courtesy of the Library Company of Philadelphia.)

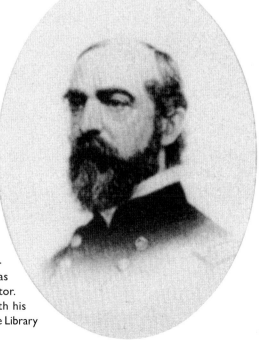

Stephen Girard and Mary Lum Girard

While the City of Philadelphia may honor Stephen Girard, who was the founder of Girard College, the primary financier of the War of 1812, and founder of Girard Trust Company and Bank, not much is known about his wife, Mary Lum Girard.

It is unclear why Mary Lum's name been undersold in a city that purports to honor its historic figures, but a clue can be found on the first floor of Pennsylvania Hospital. A large plaque honoring Stephen Girard's contributions to the hospital also mentions that his wife, Mary Lum, lies buried somewhere near the spot. Biographies of Stephen Girard indicate that, during their marriage, Mary was committed to a mental ward in Pennsylvania Hospital from 1790 until her death in 1825. Because of her special status as the wife of Stephen Girard, she was permitted to have a series of rooms and a parlor on the hospital's first floor. Other mental patients had a much harder time of it, living in rooms that Dr. Benjamin Rush (who was responsible for committing Mary Lum) described as "cold and damp in the winter, hot in the summer, lacking ventilation, stuffy and malodorous" Mary Lum's status as a mental patient no doubt had everything to do with her burial in an unmarked grave somewhere on hospital grounds. (Above, courtesy of John Kiker; opposite, courtesy of the Philadelphia Historical Commission.)

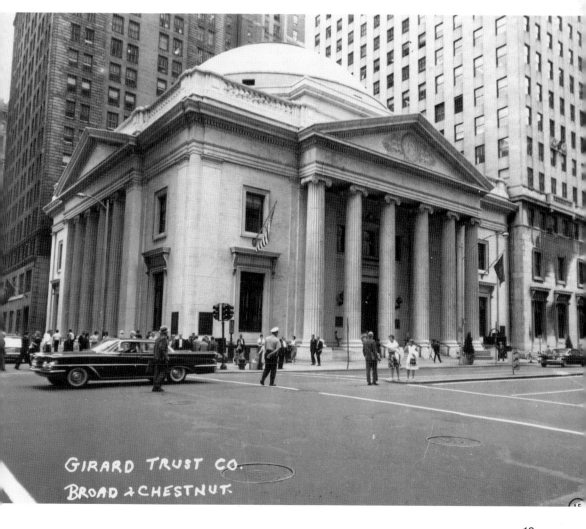

GIRARD TRUST CO.
BROAD & CHESTNUT

Octavius Valentine Catto

Octavius Valentine Catto (1839–1871), a black educator and civil rights activist, came to Philadelphia from South Carolina with his family when his father obtained his freedom from slavery. In Philadelphia, he enrolled in the Quaker-run Institute for Colored Youth (ICY). The Civil War increased his abolitionist beliefs, paving the way for his rousing Philadelphia speech in 1865 in which he praised the Emancipation Proclamation. At that time, he joined forces with Frederick Douglas and organized a committee to encourage blacks to fight for the Union. His most dramatic city fight was his commitment to end segregation of Philadelphia's trolley car system. On May 17, 1865, he boarded a trolley car in the city and refused to move when ordered to by the conductor. The *New York Times* reported the following:

> Last evening a colored man got into a Pine-street passenger car, and refused all entreaties to leave the car, where his presence appeared to be not desired. The conductor of the car, fearful of being fined for ejecting him, as was done by the Judges of one of our courts in a similar case, ran the car off the track, detached the horses, and left the colored man to occupy the car all by himself.

The report went on to say that Catto refused to move, spent the night there, and attracted a large crowd of sympathizers to his protest. Catto was made ambassador to Haiti in 1869, and in 1870 he joined (with some difficulty) the Franklin Institute. Catto was shot and killed on election day, 1871, by Frank Kelly, who had joined with a number of other whites who had been patrolling the streets to stop blacks from voting. (Courtesy of John Kiker.)

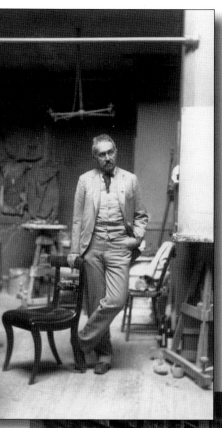

Thomas Eakins

Born in Philadelphia in 1844, Eakins went to Central High School, where he learned technical drawing. In 1886, he went to Paris, catching French realism before it evolved into Impressionism. From Paris, he wrote his father, "The big artist does not sit down monkey-like and copy a coal scuttle or an ugly woman like some Dutch painters have done nor a dung pile, but he keeps a sharp eye on Nature and steals her tools." In Paris, he learned to have no shame about bodies or sex, which would cause him trouble on his return to "the Quaker City." The year 1870 found him in his parents' house on Mount Vernon Street, where he set up a portrait studio and created pictures and portraits of society people and members of the Roman Catholic hierarchy. His sporting pictures include such masterpieces as *Max Schmitt in a Single Scull* and *Pushing for the Rail*. He exhibited at a Philadelphia gallery in 1896, an event that was ignored by the local press. When the Pennsylvania Academy awarded him the Temple Gold Medal for a portrait of an archbishop, Eakins accepted it wearing red bicycle pants, then gave the medal to the US Mint, where it was melted down. He died on June 25, 1916 and was buried in a forgotten West Philadelphia plot that remained unmarked until 1983. (Above, courtesy of the Pennsylvania Academy of the Fine Arts; below, courtesy of City of Philadelphia Mural Arts Program.)

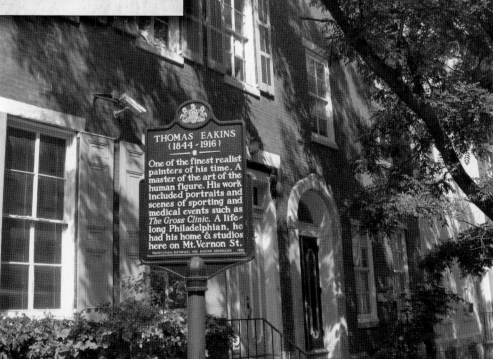

David Rittenhouse

Pictured is the Rittenhouse Hotel at 220 Rittenhouse Square. David Rittenhouse (April 8, 1732–June 26, 1796), a descendant of William Rittenhouse, who built America's first paper mill, is the namesake of the hotel and the square. A self-taught polymath who would later go on to become one of the leading scientists of the 19th century, Rittenhouse experimented with magnetism and electricity and would build his own observatory so that he could keep track of what he saw in the skies. He was a professor of astronomy at the University of Pennsylvania and was awarded many honorary degrees, including election to membership at the American Academy of Arts and Sciences. Rittenhouse was given the honor by George Washington of serving as the first director of the US Mint in Philadelphia, then the capital of the United States. The formerly named South-West Square was changed in 1825 to honor Rittenhouse. (Courtesy of the Hillier Group.)

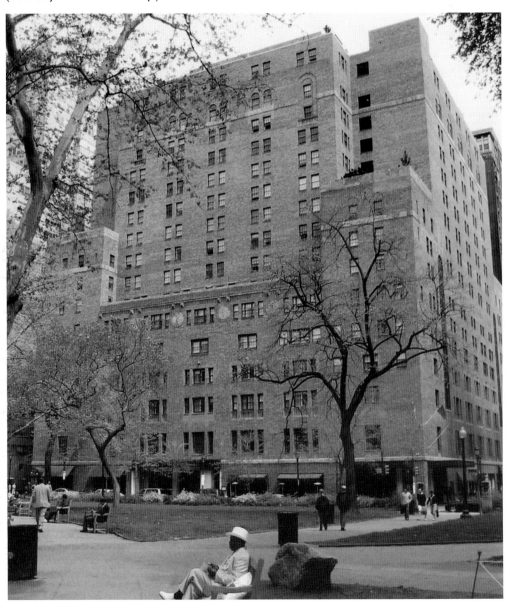

Alexander Cassatt

Alexander Cassatt (December 8, 1839–December 28, 1906), president of the Pennsylvania Railroad in 1899, helped orchestrate and expand the nation's rail system. He also developed the idea of the elevated track and track electrification. His crowning achievement was the construction of the Pennsylvania Terminal in New York City, which was demolished in 1973. He was a lover of horses and fox hunting, and he had a multiacre estate in Berwyn, Pennsylvania, called Chesterbrook. His Rittenhouse Square town house at 202 South Nineteenth Street was demolished in 1972 to make way for the Rittenhouse Hotel, pictured on the previous page. (Courtesy of H.G. Callaway.)

Cecilia Beaux

Cecilia Beaux (May 1, 1855–September 7, 1942) was an American society portraitist and was influenced by the work of John Singer Sargent. She was the youngest daughter of silk manufacturer Jean Adolphe Beaux, and her mother died days after her birth. Later, Cecilia would write, "We didn't love Papa very much, he was so foreign. We thought him peculiar." She studied at the Pennsylvania Academy of the Fine Arts when Thomas Eakins was making his mark there, though she would distance herself from him and his circle of admiring students. "A curious instinct of self preservation kept me outside the magic circle," she wrote. Sometime after she studied in Paris, she resolved to stay unmarried to devote her energies to her art. In 1895, she was the first woman to be hired as a teacher at the Pennsylvania Academy of the Fine Arts (PAFA). While walking in Paris in 1924, she fell and broke her hip. She continued to paint after the accident, though not with the same velocity. In 1933, Eleanor Roosevelt hailed her as "the American woman who had made the greatest contribution to the culture of the world." She died at age 87 and is buried in Bala Cynwyd, Pennsylvania. (Courtesy of the Library Company of Philadelphia.)

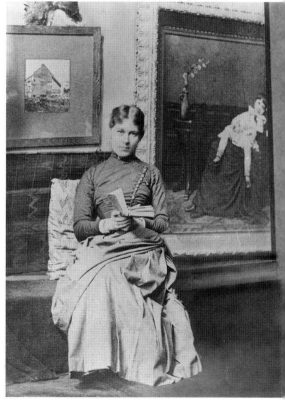

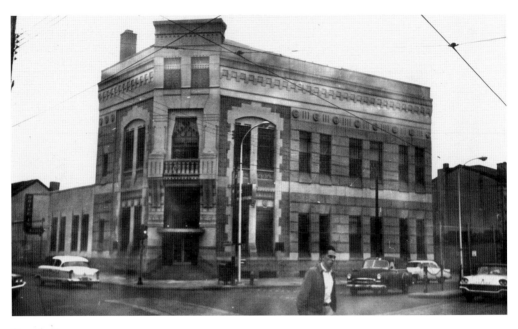

Frank Furness

Frank Furness (1839–1912) a prolific Victorian-era architect who designed over 600 buildings, was awarded the Medal of Honor for bravery for his service in the Union army. Fortunately, the flamboyant architect did not live to see his bold, eclectic style fall out of fashion with the destruction of many of his buildings in the 20th century. Furness designed the University of Pennsylvania Library, the Pennsylvania Academy of the Fine Arts, the First Unitarian Church of Pennsylvania, Laurel Hill Cemetery, Kensington National Bank at 8 West Girard Avenue (pictured above), and Philadelphia's Broad Street Station, which was demolished in 1953. Furness married Fanny Fassit in 1866 and had four children. His work influenced that of Louis H. Sullivan (1856–1924), who is generally considered to be the father of the modern skyscraper. (Above, courtesy of the Philadelphia Historical Commission; below, courtesy of John Kiker.)

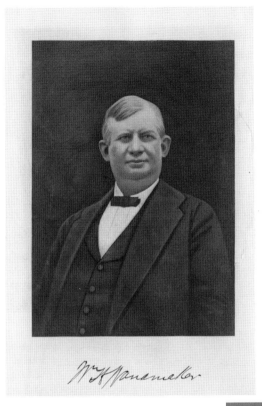

John Wanamaker

John Wanamaker was born in Philadelphia and first worked for the Young Men's Christian Association. In 1861, he and his brother-in-law opened a men's clothing store called Oak Hall. The year 1869 saw the beginning of the John Wanamaker & Company. The Wanamaker empire grew so that by 1896, Wanamaker moved his store to New York City. A staunch Protestant Christian, Wanamaker supported the temperance movement as well as Pennsylvania's (now defunct) blue laws. He was made postmaster general of the United States in 1889. Regarded favorably by his employees because of his willingness to enroll them in business classes and provide employee benefits, he was no slouch when it came to forcing male employees to take part in military drills. His net worth at the time of his death in 1922 was measured as $100 million. Friend Thomas Edison was a pallbearer at his funeral. (Courtesy of the Library Company of Philadelphia.)

Dr. William Williams Keen Jr.

Dr. William Williams Keen Jr. (1837–1932) was the first brain surgeon in the United States who became famous for the invention of new techniques for brain surgery. Keen became the medical consultant for a number of US presidents, particularly Franklin Delano Roosevelt at the onset of his paralytic illness. He married Emma Corinna Borden in 1867 and was a lecturer on surgical pathology and a professor of surgery at Jefferson Medical School. He taught artistic anatomy at the Pennsylvania Academy of the Fine Arts. At his retirement from Jefferson in 1907, he became an emeritus professor of surgery. Keen was the author of *Surgery: Its Principles and Practice*, which became the standard text for American surgeons. His descendant Dr. David Freeman is a member of Philadelphia's Franklin Inn Club. (Courtesy of David Freeman.)

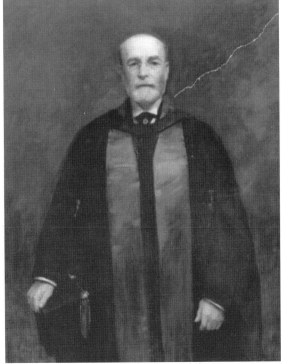

Albert C. Barnes

Albert Barnes was born in 1872 in the Kensington section of the city to working class parents. His father was alternately a plumber, mechanic, and day laborer, while his mother was active in the Methodist Church. Excelling in school at an early age, Barnes went to Central High before being accepted to the medical school at the University of Pennsylvania. He obtained his medical degree in 1892, but the physician's life was not for him. Soon, he was calling himself a "professional gambler," even while cultivating a new interest in experimental therapeutics (pharmacology) during a stay in Berlin. A period of career indecision followed, during which he worked as an advertising copywriter. Returning to Germany to study at the University of Heidelberg, he developed a product called Argyrol to treat conditions of the larynx and pharynx (and even hay fever). The discovery made Barnes a wealthy man, enabling him to indulge his passion for collecting Impressionistic, post-Impressionistic, and modern art while establishing the Barnes Foundation in Merion, Pennsylvania. In 2010, after a number of lengthy court battles, the Barnes Foundation was moved to the Benjamin Franklin Parkway. (Courtesy of the Barnes Foundation.)

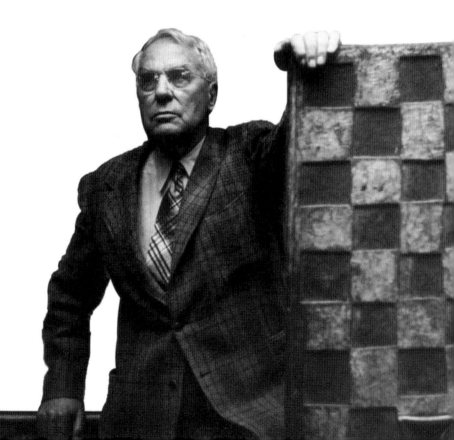

CHAPTER TWO

Modern-Age Activists and Entertainers

Essayist Agnes Repplier introduced Philadelphia audiences to Henry James after drinking whiskey with Whitman in Camden and writing that the poet's house was a firetrap because it was filled with newspapers. In Hollywood, Sam Wood turned Christopher Morley's novel *Kitty Foyle* into a popular movie. These years also saw staunchly Republican Philadelphia turn staunchly Democratic, opening the gates for Richardson Dilworth, Edmund Bacon, and finally, police baton–whirling mayor Frank L. Rizzo. At this time, Center City architect Lou Kahn produced his peculiar brand of modernism, and Vincent Kling (with Edmund Bacon at the helm) created a new downtown known as Penn Center. On the other side of the parkway, Anne d'Harnoncourt helped enhance the city's international art reputation, and the downtown gentleman-artist Emlen Etting struggled to preserve his artistic legacy on Panama Street.

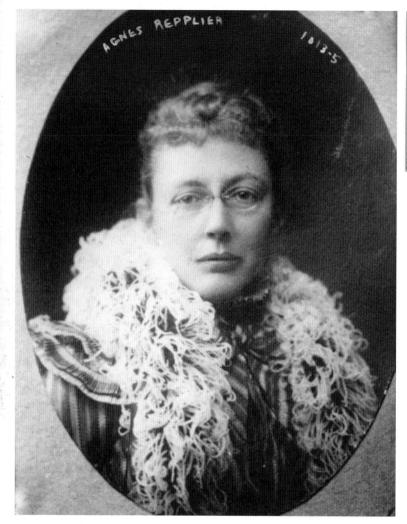

Agnes Repplier

Agnes Repplier (April 1, 1855–November 15, 1950) was an essayist and the author of a number of books, including *In Our Convent Days* (1905), about her days at the Convent of the Sacred Heart, "Eden Hall," in Philadelphia's Torresdale's section. She was expelled from both Eden Hall and the Agnes Irwin School for perceived frivolities, and a Catholic priest suggested to her that she should stick to the essay form rather than write fiction. Her essays were published in *Life*, the *Atlantic Monthly*, the *New Republic*, the *Yale Review*, and *Harper's*, among others. Repplier's books include a biography of Jacques Marquette. Often described as a shy, Catholic version of Ralph Waldo Emerson, Repplier knew the greats of her day. Walt Whitman said of her, "She strains for brilliancy, tries hard and harder and hardest until she gets her wit just where she wants it." Henry James, whom Repplier introduced to Philadelphia audiences, said that he liked her "for her bravery and (almost) brilliancy." Repplier is buried in the churchyard of St. John the Evangelist Catholic Church at Thirteenth and Market Streets in Center City. (Courtesy of Vintage Reprints.)

Sidney "Fiske" Kimball

Sidney "Fiske" Kimball (1888–1955), an architect and architectural historian, was the director of the Philadelphia Museum of Art for 30 years. Although born in Massachusetts and educated at Harvard University, Kimball became a Philadelphian in 1925 when he was appointed director of the museum. During his tenure there, Kimball had occasion to work with Philadelphia African American architect-designer Julian Abele (1881–1950), chief designer in the office of Horace Trumbauer. Kimball called Abele "one of the most sensitive designers in America" after the latter's design work on the Central Branch of the Free Library of Philadelphia. Kimball was also art advisor to presidents Franklin Roosevelt and Harry Truman before his resignation from the museum in 1955. (Courtesy of Philadelphia Museum of Art.)

Samuel Grosvenor Wood

Samuel "Sam" Grosvenor Wood was born in Philadelphia in 1884 but left for Hollywood as a young man to pursue a career as an actor. He was soon working as an assistant to Cecil B. DeMille, and in the 1920s, he began a lucrative career as a solo director, working for both Paramount and MGM. Wood's films included *Kitty Foyle*, *Goodbye, Mr. Chips*, *A Day at the Races*, and *A Night at the Opera*. He worked with the leading stars of the day, including Marion Davies, Jimmy Durant, Gloria Swanson, and Clark Gable. His 1940 Oscar-nominated movie *Kitty Foyle*, adapted from Philadelphian Christopher Morley's novel of the same name, starred a young Ginger Rogers. A political conservative, Wood testified before the House Un-American Activities Committee in 1947. His prickly personality may have won Wood some friends, but when pitted against Groucho Marx's equally stinging rapport, the result was fireworks. It is reported that Wood once said to the Marx "You can't make an actor out of clay," while Groucho quickly responded, "And you can't make a director out of wood." Wood died suddenly in 1949 of a heart attack. (Courtesy of Joe McClernan.)

Russell Conwell

Russell Conwell, who went on to found Philadelphia's Temple University, was born in 1843 and worked his way through Yale before joining the Union army, where he became a captain. After the war, he completed his law degree at the Albany Law School before becoming a working journalist for a variety of newspapers in St. Paul, Minnesota. A sea change occurred when he studied to be a Baptist minister and was made pastor of a church in Massachusetts in 1881. When Grace Baptist Church recruited him to be their pastor the following year, Conwell traveled to Philadelphia, where he remained the rest of his life. Under Conwell's leadership, Grace Baptist flourished to such an extent that plans were made for a new church, renamed the Baptist Temple Church, at Broad and Berks Streets. Conwell then made plans to start a school specifically for working people, and shortly after this, he raised funds for a hospital, later named Temple University Hospital. Conwell, who wrote some 40 books, died at age 82. (Courtesy of Temple University Urban Archives.)

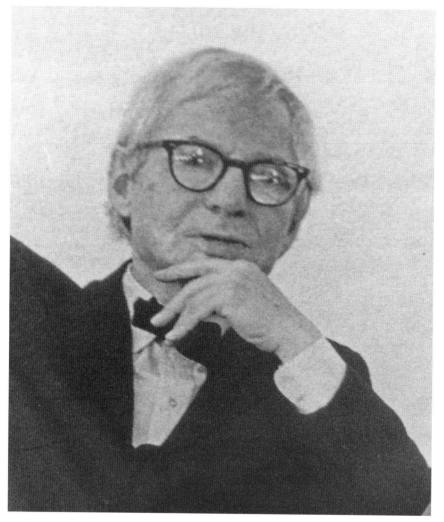

Louis Kahn

"[Louis Kahn] was a totally loveable human being," remembers Philadelphia architect Alvin Holm. "I don't think there wasn't anybody who didn't like him—cab drivers, professors; he was charismatic, absolutely. But I think he was wrong. I think he took us down a path that led nowhere. And I think that's one of the problems with modernism in general. It's idealistic without any particular ideal."

Holm's image conjures up T.S. Eliot's "The Hollow Men" or Tom Wolfe's view of modern architecture in *From Bauhaus to Our House*. Wolfe's view is unambiguous: the architecture world, like the art and literary worlds, is dominated by critics and academia, meaning that its buildings leave most people cold. Much of these "ideal-less" buildings, Wolfe says, are the products of architects who only want to outdo the competition in avant-garde designs.

Holm believes that Kahn wanted to go back to the beginning, or to Walter Gropius's Ground Zero, that idealless world where the history of architecture does not exist. "Kahn would sit on a stool frequently and his disciples would sit on the floor, and he'd look down for the longest time and then he'd look up and say, 'I'd like to remember that moment when the walls parted and the columns became.'" "That's quite a poetic saying," Holm points out, "but there never was such a moment, because there were columns before there were walls, there were columns before there was anything structural." (Courtesy of Alvin Holm.)

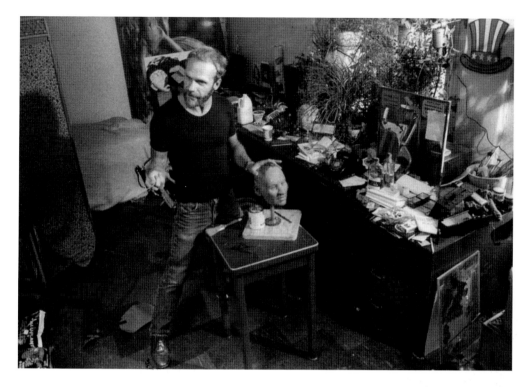

Frank Bender

Frank Bender, a forensic sculptor, reconstructed the faces of the dead and the missing. Bender worked with the Philadelphia Police Department on many unsolved murders and based a large part of his sculptural reconstruction on both forensic science and his own intuition. Bender's work led to the solving of many crimes that would otherwise never have been cracked. Bender's life and work were chronicled in the 2008 best-selling book *The Girl with the Crooked Nose* by Ted Botha, in which Botha describes the artist's working methods, such as boiling the decomposed heads of murder victims in order to reconstruct a viable likeness. Frank Bender died of on July 28, 2011, at the age of 70 of pleural mesothelioma. (Courtesy of Vanessa Bender.)

Sally Starr

Sally Starr was born Alleen Mae Beller in Kansas City, Missouri, in 1923. She adopted the name Sally Starr in 1941. She was the second eldest of five girls but one of seven children. At various times, she was considered a highly rated deejay and a talented announcer, writer, and producer. She started the Philadelphia-based *Popeye Theater* in 1955, a 30-minute Channel 6 variety show that included cartoons, live acts, Western shorts, *The Three Stooges*, and guests like Roy Rogers and Dale Evans, Chuck Connors, Jerry Lewis, Jimmy Durante, Nick Adams (famous for playing Johnny Yuma), and Chief Halftown. (Courtesy of the estate of Sally Starr.)

Lamont Steptoe

Lamont Steptoe is the author/editor of more than 15 poetry collections—including *Meditations in Congo Square* (about the mass burial of slaves in Philadelphia's Washington Square), *A Long Movie of Shadows*, and *Cat Fish and Neckbone Jazz*, was born in Pittsburgh. He was a Vietnam veteran, and his poems about war and peace are among his most powerful. The adventurous world traveler, activist, and photographer has visited places like Cuba and Nicaragua. As a journalist who once worked for ABC, Steptoe told an interviewer in 1998 that "People who are in journalism, whether it might be broadcast or print, are some of the most conservative people in the world. They're not out to change the status quo. They want the status quo to stay the same. They're not about telling the truth; they're about controlling information." (Courtesy of Lamont Steptoe.)

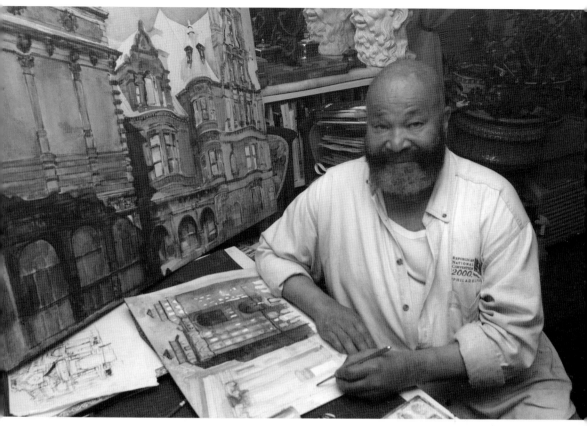

Noel G. Miles

Noel G. Miles's paintings of Philadelphia City Hall can be found in the book *The Splendors of Philadelphia's City Hall: An Artist's View*, published in 2002 with an introduction by Greta Greenberger and a preface by then mayor John F. Street. When Britain's Prince Charles visited Philadelphia several years ago, the city presented him with a gift of one of Miles's paintings, which today hangs in the royal palace at Highgate. Miles, who calls himself a "child of Affirmative Action," was the first black member of the Philadelphia Watercolor Club in the 1940s. He has worked for the *Philadelphia Bulletin* and the *Philadelphia Daily News* and was the art director for some years at WPVI-TV. His stories about local newscasters and visiting celebrities can fill volumes. Miles was awarded the Philadelphia Watercolor Society's prestigious 2013 Dawson Prize. (Courtesy of Jim Talone.)

Alvin Holm

Philadelphia architect Alvin Holm describes himself as a "once happy modernist." The affable white-haired head of a small firm on Samson Street in Center City says he changed his mind about modernism about 20 years after getting his master's degree in architecture at University of Pennsylvania. "I always loved the old style. But when I began teaching architecture . . . something happened."

Holm, who once studied with Louis Kahn and Vincent Scully, remembers being charmed by Kahn but compares what Kahn did to the kind of amnesia that old people get. "That's what modernism did. How can you call that progress? That's called losing your marbles."

"I was an unapologetic modernist until 1976 Bicentennial got underway with its focus on looking back and taking stock. These were also the years when most architects had little respect for preservation and traditionalism. Architects, who celebrated Classicism, such as the work of Henry Hope Reed, were seen as part of a lunatic fringe."

Holm has his own version of what constitutes a lunatic fringe. Take Frank Lloyd Wright, for instance. While insisting that he has admiration for Wright's work, Holm faults Wright's towering ego for taking credit for the Prairie style when the opposite is true. "A lot of those buildings were done by his peers and in a lot of cases a little bit earlier, but Wright gets credit for it all around the world. The Arts and Crafts movement was an international movement long before Wright came on the scene." (Courtesy of Alvin Holm.)

Mayor Frank Rizzo

Mayor Frank Rizzo, or "the Big Bambino," was a towering hulk of a man. Tough, resilient, stubborn, and cut from a John Wayne mold, the mayor could also be charismatic and warm. In an interview conducted shortly before his death in the early 1990s, he spoke tenderly of a police officer friend dying of AIDS. During his time as police chief, however, officers under him routinely rounded up people on the street. The author was taken into custody one summer night in 1975 while walking in the city; police were looking for a male suspect with red hair, and inside the van were 10 male redheads, plucked from city sidewalks, who were subsequently arranged in a lineup. Rizzo's charm and charisma could win over his staunchest enemies. During one interview, Rizzo spoke in a style that he used to disarm his critics, finishing with a friendly "Anything you want to say about me you can say it, anything you want to add— no problem." (Author's collection.)

Warren William "Barney" Cunningham

Warren William "Barney" Cunningham, a Philadelphia architect, set his own style by becoming a city architect the hard way: he earned a bachelor's degree in architecture from the University of Pennsylvania on the GI Bill after serving as a Navy fighter pilot in the Pacific theater during World War II. Described as "quietly confident," Cunningham avoided the limelight, unlike his more flamboyant contemporaries Robert Venturi and Louis Kahn. A notable teacher of young architects, he was a principal of one of Philadelphia's most honored firms, Geedes Brecher Qualls Cunningham. The firm's work included the Police Administration Building, the American Embassy in Pakistan, and the campus of Richard Stockton State College. Cunningham died at age 90 in his home in Wyndmoor, Pennsylvania. (Courtesy of Rosemarie Fabien.)

Sam Katz

Sam Katz ran three times as a liberal Republican candidate for mayor and almost ran in the 2011 Democratic primary against Mayor Michael Nutter. Katz's aborted 2011 mayoral campaign came sometime after he realized he was not going to get anywhere in Philadelphia as a Republican and so switched political parties. In the end, even that did not work. The machine in charge had its own hierarchy of favorites, and Katz was not among them, despite the fact that he seems more than suited for the mayor's office. Well read, articulate, conversational, and urbane, Katz has all the exterior attributes that would put him in the running in any big city in America—except Philadelphia.

Philadelphia's Democratic roots, after all, go back to 1951, a year when the local press made a point of lamenting 60 years of boss Republican rule. Republicans were the machine then, with Mayor Bernard Samuel's 10-year term as mayor ending a cycle that was largely broken by Franklin Delano Roosevelt's New Deal and the ensuing massive immigration of southern blacks into the Quaker City. Realizing that the influx of new residents could provide a windfall of votes, city Democrats courted the newcomers to help win elections. The strategy worked, helping elect Democrat Richardson Dilworth as mayor in 1951, and a new machine was born.

Katz's political withdrawal from the 2011 mayoral race had the markings of a NASCAR race car coming to screeching stop. The press reported he was dropping out for "personal and political reasons, though the man himself has said, "never say never."

The mild-mannered Katz has done what few seem to manage successfully: he has reinvented himself in the style of Arthur Rimbaud, the 19th-century French poet who once wrote, "You must change your life."

"Philadelphia is my passion," Katz asserts. "Passion" in this case refers to a new project, *Philadelphia: The Great Experiment*, a series of documentary films focusing on the history of the city and historical subjects outside city and state boundaries. (Author's collection.)

Dan Rottenberg
Philadelphia editor and writer Dan Rottenberg is the author of 10 books, including *Death of a Gunfighter* (2008) and *Main Line Wasp* (1990), the memoirs of iconic Philadelphia civic leader W. Thacher Longstreth. The former executive editor of *Philadelphia Magazine* and managing editor of the *Chicago Journalism Review* has never been one to run from controversy. As former chief editor of the *Welcomat* (now the *Philadelphia Weekly*), Rottenberg stood his ground when challenged by militant ideologues. He lives in Philadelphia with his wife, a piano teacher, while his two grown daughters make their home in New York City. Rottenberg told the *University of Pennsylvania Gazette*, "My grandfather, Marc, became a disciple of Mordecai Kaplan, founder of Reconstructionism, the notion that Judaism is not so much a religion as a civilization that has constantly been 'reconstructed.' My relatives taught me that great ideas do not begin as a minority of one. They often occur simultaneously to many people in isolation, but the ideas perish unless a community connects such people." (Courtesy of Dan Rottenberg.)

Emlen Etting

Emlen Etting and his wife, Gloria Braggiotti Etting, hosted world-famous artists and celebrities in their Center City Panama Street town house. A painter, sculptor, and illustrator, Emlen was born in Philadelphia but attended schools in Switzerland and Newport, Rhode Island before graduating from Harvard. In Paris, he studied under Andre Lhote, a teacher who was hard on his male students but preferential to pretty females. Emlen produced a number of experimental films, and his works are in a number of museums. He had a vast knowledge of French literature. He worked in the psychological-warfare division of the Office of War Information during World War II. His sculpture, *Phoenix Rising* (1982), also known as "the Dilworth sculpture" in honor of former mayor Richardson Dilworth, was installed alongside Dilworth Plaza at Philadelphia City Hall. "The white, epoxy-covered aluminum, abstract sculpture is 8 feet wide and 12 feet deep and is set on a reinforced concrete base. It soars 20 feet from its base, attached with concealed bolts and rivets to symbolize, like wings and flames of the Phoenix Rising, Dilworth's dream for Philadelphia's rise from urban decay" wrote Kenneth C. Kaleta, PhD, in *With the Rich and Mighty: Emlen Etting of Philadelphia*. Emlen died at age 88 in 1993 of Parkinson's disease. (Courtesy of Kay Square Press, Inc.)

Grace Kelly

Grace Kelly, who grew up in the city's East Falls section and the daughter of a millionaire brick contractor, blossomed as one of America's top actresses of the 1950s. She made fewer than a dozen films. But her big break—as the rigid Quaker wife opposite Gary Cooper in *High Noon*—was followed by *Mogambo* (Clark Gable and Ava Gardner) and a Best Supporting Actress Oscar.

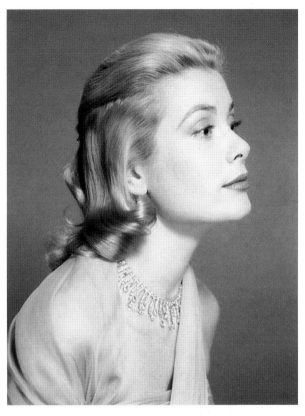

It earned Grace Kelly more attention in Hollywood, but a flurry of films in the mid-1950s—the Alfred Hitchcock thrillers *Dial M for Murder* and *Rear Window*, along with *The Country Girl* (she won a Best Actress Oscar at 26), *To Catch a Thief*, *High Society*, and *The Swan*—particularly cemented her stature in films that have evolved into classics.

That remarkable streak—and, of course, her beauty didn't hurt—elevated Grace Kelly to American darling. Her elegant manner of dress—hats, pearls, and white gloves—became the order of the day. *Women's Wear Daily* and *Time* magazine featured her on their covers in the 1950s.

But Grace Kelly ultimately chose a different path when she and Prince Rainier, a wealthy bachelor, met at the Cannes Film Festival in May 1955. Their courtship led to the altar in less than a year. Of course, Grace Kelly had money and the power of celebrity to ensure that she wore a gown for the ages. But this elegant creation—complemented by shoes, headpiece, and a net veil designed to show her face—was a wedding gift from Metro Goldwyn Mayer Studios. The task of designing it went to Helen Rose, an Oscar-winning designer who created Kelly's costumes for two of her films. About 35 members of the studio's wardrobe department worked on the dress for six weeks. Photographs of the period depict matronly types in wire-rim glasses hard at work on the gown, laboring under top-secret conditions. Outsiders were forbidden to see the dress; security was so tight that the gown's blueprint was locked up at night. In those days, Grace Kelly was so beloved that everybody following the barrage of pre-wedding news wanted her dress to be a masterpiece.

In 1956, Princess Grace of Monaco, shortly after the wedding, donated her gown to the Philadelphia Museum of Art. She retired from Hollywood at 27 and never made another film. But her royal life brought a new fame as a Monaco ambassador, as she turned to charitable endeavors and eventually had three children.

Princess Grace was just 52 when she suffered a stroke while driving and died of injuries in a September 1982 car crash.

The Philadelphia Museum of Art hosted Fit For a Princess: Grace Kelly's Wedding Dress, an exhibit that commemorated the 50th anniversary of the royal wedding. Grace Kelly's wedding gown is periodically exhibited in a small section of the first-floor costumes-and-textiles wing of the museum. The regal gown—classic ivory in color, with many frontal buttons, a bell shape, ivory lace down the back, and long sleeves and high collar—puts to shame the dresses that pass for wedding gowns today. (Courtesy of Vintage Reprints.)

Edmund Bacon

Edmund Bacon (1910-2005) was one of the most important city planners in the 20th century. Born in West Philadelphia into a Quaker family, he graduated from Cornell University with a degree in architecture in 1932 and then spent a number of years in China working as an architect. After returning to the United States, he studied with Finnish architect Eliel Saarinen and then joined the Better Philadelphia Exhibition, a sensational exhibit that showed the city's projected future in 1982. Bacon's career as a city planner accelerated with the election of Joseph S. Clark Jr. as mayor in 1951. At the time of his death in 2005, he had served under four mayors and had remade large areas of the city, like Society Hill and Penn Center. Bacon lived at 2100 Locust Street for many years while also maintaining a house in Chester County. Often described as prickly and curmudgeonly, when asked what his greatest life project was, the father of actor Kevin Bacon responded, "Philadelphia." (Author's collection.)

Anne d'Harnoncourt and Joseph Rishel

Anne d'Harnoncourt and Joseph Rishel, major players in the Philadelphia and international art worlds, together helped transform the Philadelphia Museum of Art (PMA) into one of the top five art museums in the country. Born in 1943 and raised in a Central Park West apartment filled with art and books, Anne was the daughter of Rene d'Harnoncourt, director of the Museum of Modern Art. Anne attended Radcliff in Cambridge, Massachusetts, and soon followed in her father's footsteps, working in a number of museums before coming to PMA to work with the modern-art collection. From 1982 until her sudden death in 2008, she served as the director and chief executive officer of the museum, enlarging the collection of modern art to include works by Jasper Johns, Frank Stella, and Claes Oldenburg. A statuesque woman with a dignified manner, Anne once remarked to a reporter, "Everyone thought because I was tall that I should be terrific at things like basketball. I took up fencing instead." Awarded many prizes and honors for her work at the museum—including the Chevalier dans l'Order des Arts et des Lettres, Republic of France, 1995—her specialty was the work of Marcel Duchamp. At their Center City town house, she and husband Rishel were noted for their brilliant dinner parties. At an intimate press dinner with d'Harnoncourt and painter Thomas Hines at the Waterworks Café two years before her death, wearing her customary tweeds and scarves as well as a large piece of silver or copper jewelry, Anne shared stories and many art memories that kept her guests listening (over good food and wine) for hours. (Courtesy of Philadelphia Museum of Art.)

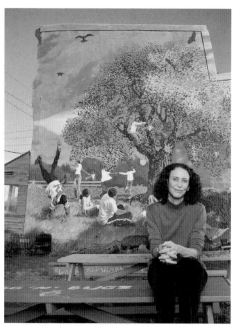

Jane Golden Heriza

Jane Golden Heriza, artistic director and founder of the Philadelphia Mural Arts Program (MAP), is a Philadelphian by adoption. The California artist was active in mural making before and during the 1980s in Los Angeles. She founded the MAP in Philadelphia in the early 1990s as the Philadelphia Anti-Graffiti Network with a goal of helping combat inner-city graffiti and delinquency. The transformative program resulted in Philadelphia's nationwide reputation as the "City of Murals," with more than 3,000 interior and exterior works. Golden's dedication to the project, often described as fierce and unwavering, has brought many honors to her and to the city. She was awarded the Visionary Woman Award from Moore College of Art and Design in 2003 and the Clara Barton Outstanding Humanitarian Award of the American Red Cross in 1999, and in 2003, she was selected as a USA Eisenhower Fellow. (Photograph by Shea Roggio; courtesy of *Philadelphia Magazine*.)

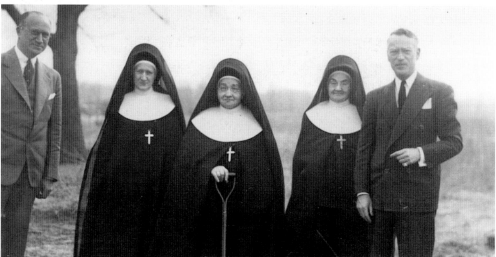

Frank V. Nickels

Pictured on the left, Frank V. Nickels (1891–1985), a Philadelphia architect educated at Drexel Institute (class of 1914), designed schools, auditoriums, convents, churches, rectories, and private dwellings. His projects included 1521 Spruce Street, the Frances Plaza Apartments at Lombard and Twentieth Streets, the Germantown home of Alfred R. Smith, 401 Wellesley Road, and Nazareth Hospital for the Sisters of the Holy Family of Nazareth in Northeast Philadelphia. He did much of his work for the Archdiocese of Philadelphia and had offices in Center City at 34 South Seventeenth Street and 15 South Twenty-first Street. Nickels designed his own home at 40 Albemarle Avenue in Lansdowne, Pennsylvania. A collection of his blueprints can be found at the Athenaeum on Washington Square. Above, Nickels poses with the Sisters of the Holy Family during the ground-breaking ceremony at Nazareth Hospital. A lover of classical music and a collector of art, he married the former Pauline Clavey, an opera singer from the city of Wilmington. Frank V. Nickels is the author's grandfather. (Courtesy of Nazareth Hospital.)

Deen Kogan

Deen Kogan was "Philadelphia Theater" long before everybody and their grandmother jumped into the act. With her husband, Jay, Deen bought what later became the Society Hill Playhouse (SHP) in 1959, when the South Street area was anything but a *Philadelphia Style* photo opportunity.

"The building was built in the early 1900s. It was originally a beneficial hall, where weddings, parties and Bar Mitzvah's took place. It was used for many other things over the years. During the WPA era it was used as a theater, and somewhere along the line it became a mattress factory," according to Ms. Kogan. Through the years, the building went through many changes. "When Jay and I got the building all the copper had been stripped out. It had been a Bingo Church with a Catholic priest and a gorgeous altar upstairs that took six men to carry out. We searched for two years for this building but it would take another year to make it suitable for audiences," Ms. Kogan recalls.

The Kogans had friends help them spruce up the place—one project was painting the men's room. After that, they received a $5,000 grant from the Pennsylvania Council on the Arts, which enabled them to begin a street-theater project. Far from a prima donna enterprise, the project involved a huge flatbed truck with a company that went into every Philadelphia neighborhood with original shows, "designed," as Ms. Kogan says, "for both children and adults," an almost impossible thing to do under the best of circumstances. "People used to say, if you rode with me on that truck you'd come to know the city by the police stations and the bakeries," Ms. Kogan added with a laugh. Although these were the tumultuous 1960s during the time of the Martin Luther riots, the Kogan's flatbed theater truck was a model of racial integration.

Philadelphia was not a theater town when SHP opened its doors, although there were the pre-Broadway theaters like the Forrest and the Walnut. After World War I came the burgeoning of community theater; the close of World War II saw the birth of regional theater. (Courtesy of Deen Kogan.)

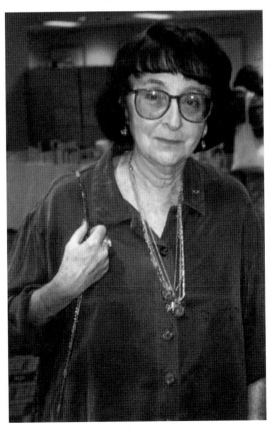

Dr. H.G. Callaway

Dr. H.G. Callaway, one of Philadelphia's few working philosophers, taught in various American and European universities as well as in the University of Ibadan in Nigeria. His many books include *The Conduct of Life* (2006), *William James: A Pluralistic Universe* (2008), and *Memories and Portraits: Explorations in American Thought*. Although he is a staunch lover of the city, the philosopher in Callaway is always present, such as when he wrote in *Memories and Portraits*, "When returning to the city after a long stay overseas in Africa and Europe, I saw that the old neighborhood, and adjoining areas, had turned into a vast tract of social disaster, and I knew thereby that something very basic was wrong in Philadelphia. Large areas of the city were no longer places where people chiefly worked and married and brought up children." (Courtesy of H.G. Callaway.)

A.D. Amorosi

A.D. was born in South West Philadelphia and says that he started writing from an early age, "penning the scripts of solo improvisational sketches and monologues onto cassette tapes." He says that he loves his wife, only known as "Glamorosi," and his greyhound Django. "They're my world. I also love my parents. They are everything to me."

Growing up, A.D. says that he wanted to be Cary Grant and Groucho Marx. "I think I achieved that," he adds.

In true A.D. style, he calls himself a "Bowie kid, glam rock kid, avant-garde jazz kid, Broadway kid, Ray Charles kid, Johnny Cash kid, Sinatra/ Dean Martin kid, James Brown kid, disco kid, and a punk rock kid." Mention favorite authors to him and he'll say, William S. Burroughs and Tom Wolfe.

"I'm Philadelphia schooled, attended Temple University, and did a year's worth of the foreign exchange documentary film/theater criticism programs in London, England. I had my own theater company, operated clubs between Philly and NYC. Then came my job at *Philadelphia City Paper*, which was my first big print gig. I have to say that in those days I wrote in a mean-assed first person sort of way—using the theory that gossip was the real truth UNTIL that became so . . ." A.D. does not finish his sentence; any reader can easily fill in the blanks. Concurrent with *City Paper* came writing gigs for the *Philadelphia Inquirer*, *Philly Style Magazine*, *Magnet*, *Filter*, *ICON Magazine* and, as A.D. says. "many, many more." A.D. also says that he does the *Glamorosi Magazine* website with his wife of the same name, "where we talk about everything." (Courtesy of *Glamorosi*.)

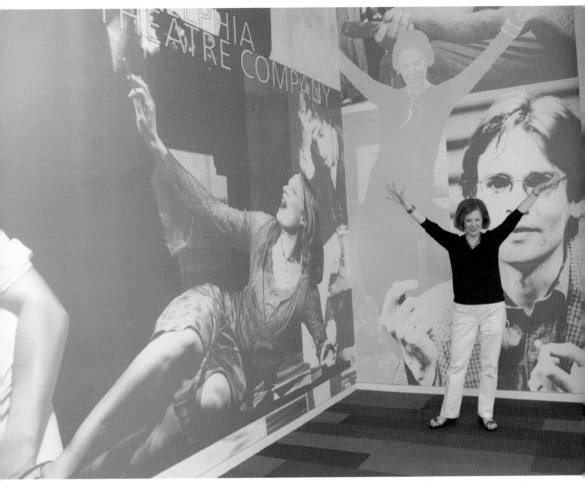

Sara Garonzik

Sara Garonzik became the Philadelphia Theatre Company's director and producer in 1982, and Philadelphia theater world has never been the same since. Garonzik's genius for selecting provocative new plays has meant more than 100 world/ Philadelphia premiers, including exciting new work by Terrence McNally, Christopher Durang, Naomi Wallace, and Bruce Graham. In 2007, Garonzik received the 2007 Achievement Award from the American Association of University Women; the following year, she was awarded an Arts Pioneer Award. Opening night at Philadelphia Theatre Company without Sara in attendance is always an unhappy occasion. Her energy contributed to the successful 2008 opening of the company's new home, the Suzanne Roberts Theatre on South Broad Street. The play that brought the company into the new era was McNally's *Unusual Acts of Devotion* with Faith Prince and Richard Thomas. (Courtesy of Jim Talone.)

Vincent Kling

Vincent Kling, Philadelphia's first "green" architect, and the son of a builder, was born in 1916 and died in November 2013, leaving a proud legacy that too often gets eclipsed by architects of lesser stature. Kling believed that architecture should be "for the people" and was the first architect in the city to incorporate green spaces, gardens, and spaces for retail. In many ways, his work succeeded in bringing the middle class back to the city. Educated at Columbia University and the Massachusetts Institute of Technology, the young Kling first worked for a New York firm until beginning his Philadelphia architectural odyssey in 1946. Kling's stamp on the city grew to monumental proportions in the 1960s and 1970s but had its first spurt in the 1950s when he joined with city planner Edmund Bacon in the creation of Penn Center, the first office complex in the city since the Great Depression. By the early 1970s, the Kling firm was the largest architectural firm in Pennsylvania, with over 400 employees. Kling's works include the Municipal Services Building, the Philadelphia Stock Exchange (now the Sofitel Hotel), and the Philadelphia Mint Kling, which won numerous awards (including the Samuel F.B. Morse Medal by the National Academy of Design in 1968 and 1972). (Courtesy of Chuck Schultz.)

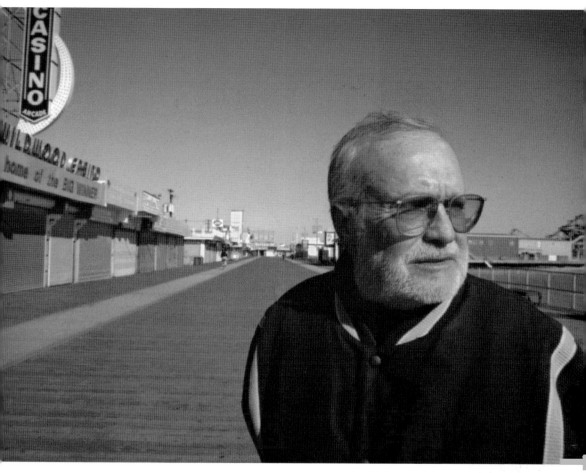

Bob Ingram

Bob Ingram is a writer/journalist/editor whose work has appeared in *Philadelphia Magazine*, *Atlantic City Magazine*, *South Jersey Magazine*, the *Philadelphia Daily News*, *Philadelphia Weekly*, and *Atlantic City Weekly*, among others. In the 1970s, Ingram was the editor of Philadelphia's *Distant Drummer* newspaper, an alternative weekly referred to in those days as an "underground newspaper." The *Drummer* covered many stories overlooked or ignored by the mainstream press and gave considerable coverage to the merging beat scene in literature and politics. The newspaper featured many writers who later went on to become well-known journalists or authors. It was considered a must-read publication for anyone interested in the social and cultural upheaval of the 1960s and 1970s. He has also cowritten, coproduced, and narrated a documentary film about the Boardwalk in Wildwood, New Jersey, called *Boardwalk: Greetings from Wildwood By-The-Sea*. (Courtesy of Bob Ingram.)

Warren Muller

Warren Muller, Philadelphia sculptor/artist, was born in the Bronx to Eastern European Jewish parents. Muller likens his childhood to the zaniness of a Federico Fellini film. "It was a museum in the streets," he says," full of color, noise, and activity."

"My parents died in 1976, just six months apart. They had a dry cleaning business, so we always had a storefront. I have an estranged sister a few years older than me. I tried to interest her in me, but that didn't work. So you go and make your own family," he said

From the Bronx he went to the Hartford Art School and then traveled to the island of Paros in Greece, where he enrolled in the Aegean School of Fine Arts. On the island, he met a photographer from Philadelphia who invited him to come to the city and enroll in the Philadelphia College of Art. After this, he got involved in documentary filmmaking and the world of dance, leaving Philadelphia often to travel and live in San Francisco, New York, and Berlin. Still, he always managed to find his way back to the Quaker City as if under the spell of a dragging vortex. "I've been working here so long, you know, but the city ignores you—in spite of this I go about my business," he says. (Author's collection.)

Diane Burko

This Brooklyn-born Philadelphian has traveled to both the North Pole and to Antarctica in the same year in order to complete her landscape–painting-photograph project documenting the effects of glacial geology as related to climate change. A graduate of Skidmore College and from graduate school at Penn Burko, she became a teacher for a short while at Princeton and at the Pennsylvania Academy of the Arts. Her first public notice as an artist was a 1976 review of her work at a New York gallery by *Village Voice* critic David Bourdon. Burko began her landscape-photography work in 1977. Her work can be found in the permanent collections of many museums, including the Philadelphia Museum of Art, PAFA, the Art Institute of Chicago, and the James A. Michener Art Museum. (Courtesy of Diane Burko.)

Stuart Feldman

Stuart Feldman, lawyer, lobbyist, and founder of Philadelphia's Constitution Center, was born in 1937 and died in 2011. He was proof that a modest demeanor is not an impediment to accomplishing great things, and the *Washington Post* noted that Feldman was "a driving force in the 1960s and '70s for recognizing the service and sacrifice of veterans with improved health care and educational opportunities." In 1977, Fortune reported that Feldman "won billions of dollars for veterans programs." *Washington Post* columnist Colman McCarthy wrote, "For Stuart Feldman, the people who really scorned Vietnam veterans were not the occasional anti-war protesters, but members of Congress who sent them to war and then willfully looked away when they came home in desperate need of health care and education . . . His advocacy was of the rarest kind in Washington: relentless, informed and humane. If there were a medal of honor for valor in defending the rights of veterans, Stu Feldman would surely have earned one." (Courtesy of the author.)

Mark Segal

Mark Segal (right, with friend and former partner Tony Lombardo), pioneer of LGBT journalism and often referred to as "the dean of American gay journalism," was one of the founders of the Gay Liberation Front (GLF), an early radical civil rights organization. From GLF, Segal went on to find the Gay Raiders, he made national headlines in 1973 when he stormed Walter Cronkite's live CBS news broadcast and held up a yellow banner reading "Gays Protest CBS Prejudice." The incident was reported by the *New York Times*. Segal, who went on to become friends with Cronkite, also disrupted *The Tonight Show* with Johnny Carson, a broadcast by Barbara Walters on *The Today Show*, and Philadelphia's *The Mike Douglas Show*. In 1976, he founded the *Philadelphia Gay News*, a successful weekly publication that has left an indelible mark on the city. From being an outsider and radical, Segal has transitioned to major-player status and has received accolades from both Hillary Clinton and Barack Obama. (Courtesy of Gail Didich.)

EQUALITY FORUM AND NBC10
INVITE YOU AND A GUEST

EQUALITY FORUM 2012
VIP KICKOFF

GERSHMAN Y
401 SOUTH BROAD STREET

WEDNESDAY, MAY 2
6:30 TO 8 P.M.

DISTINGUISHED SERVICE AWARD
MEL HEIFETZ

SPECIAL GUESTS
ISRAELI DELEGATION

13TH ANNUAL GAY AND LESBIAN ART EXHIBIT OPENING
ISRAELI PHOTOGRAPHER DAVID ADIKA

THIS IS AN INVITATION-ONLY EVENT
RSVP TO CHIP@EQUALITYFORUM.COM
BY FRIDAY, APRIL 20TH

SPONSORED BY:

NBC 10

THE UNIVERSITY OF THE ARTS

The Consulate General of Israel Philadelphia

The Gershman Y

Malcolm Lazin

Malcolm Lazin, LGBT rights leader and founder of Equality Forum (1993), which is dedicated to creating a better understanding of LGBT issues and history. Lazin has been a federal prosecutor, an assistant US attorney (1970–1974), and president of both the Philadelphia Waterfront Developers Corporation and the Penn's Landing Development Corporation. The recipient of numerous awards, such as the Center City Proprietors Annual Philadelphia Business Award and *Philadelphia Magazine*'s Best Entrepreneur Award, Lazin's biggest impact so far is his work with Equality Forum, a multivenue, weeklong event that has attracted national and international figures, from Hollywood celebrities to political icons like Cuba's Mariela Castro. He has also worked as executive producer of documentary films like *Saint of 9/11*, which tells the tale of Franciscan friar Mychal Judge, who died during the World Trade Center attack, and *Jim in Bold*, about a young, gay, artist from rural Pennsylvania who experienced persecution and committed suicide because of local homophobia. (Courtesy of Malcolm Lazin.)

The Franklin Inn Club

The Franklin Inn Club, Philadelphia's club of notables, was founded in 1902 as a strictly literary club for men who had published a book (excluding textbooks) or who were contributors or publishers of literary magazines. Poet W.B. Yeats, Christopher Morley, and *Dracula* author Bram Stoker were all visitors to the club. Its founding president was Dr. S. Weir Mitchell, a neurologist and novelist. In 1907, Dr. William White, a surgeon and medical author, orchestrated the purchase of the club's present building at 205 South Camac Street. The club's all-male membership ended in 1980, and present members include physicians, lawyers, judges, bankers, and artists of many types. Among them are Thomas Carroll, an expert on Wissahickon German mystics, Johannes Kelipus, and Walton Van Winkle, an artist/writer and descendant of Cornelius Van Winkle, the publisher of Washington Irving's first book. Other notables include George Fisher, Richard Goldberg, Nathan Sivin, Gregory M. Harvey, David Freeman, H.G. Callaway, Jan Gordon, Wesley D. Parrott, Brearley Karsch, Melissa Hancock, and Mary and Scott Stewart. (Both, courtesy of Jim Talone.)

Pearl S. Buck

Born in West Virginia, Buck (1892–1973) grew up in China, the daughter of Christian missionaries. After college, she returned to China and remained until 1934. She began writing novels in the 1920s, publishing *East Wind, West Wind* in 1930, following it in 1932 with *The Good Earth*, which won many awards, including the Pulitzer Prize. She won the Nobel Prize for Literature in 1938 and was the author of many other works of fiction. In her Center City house at 2019 Delancey Place, she compiled her 1972 short story collection, *Once upon a Christmas*. Other holiday stories like "Christmas Miniature" (1957), "The Christmas Ghost" (1960), and "Christmas Day in the Morning" may also have been written in the Delancey Place town house. The 9,000-square-foot, five-floor town house was purchased in 1964 as the home of Pearl Buck and the Pearl S. Buck Foundation. While the basement and first floor were renovated for use as foundation space, the second floor was designed to house the dining room, a formal drawing room, and the solarium, or sunroom, where Buck had large numbers of plants.

With the famous Rosenbach Museum & Library just a few doors away at 2008–2010 Delancey Street, it is no wonder that Buck saw this area as a special part of Center City. It is said that in Center City, she dressed like a society matron and was called "Miss Buck," but when she was her Bucks County home, she was far more informal.

"Why did I choose Center City, you ask?" Pearl S. Buck once wrote. "Because there was a street, there was the house, there were the people. There, too, was the tradition of brotherly love." Buck also wrote that no matter where she lived, there were always elements of the Chinese. "Sooner or later into every room in any house I own the Chinese influence creeps."

At 2019 Delancey, the third-floor library contained a baby grand piano, the famous "Good Earth Desk," an ancient Chinese drum on a pedestal which acted as a coffee table, as well as leather-bound editions of her books given her as gifts by her publisher. Much of the furniture was imported from the Buck house in China, namely the rose-and-tan Peking rugs, the Blackwood chairs, and a daybed. (Courtesy of the Pearl Buck Foundation.)

Sylvester Gardenzio Stallone

New York–born actor and screenwriter Sylvester Gardenzio Stallone attended Lincoln High School for a while in Philadelphia and then went on to make movies after a short period of homelessness in New York City. He is famous for his action roles, like Rocky Balboa in the Rocky film series. Today, the props from those films are housed in the Smithsonian Institution, and a bronze statue modeled after the actor, "the Rocky Statue," cast in 1980 for the film *Rocky II*, was donated by Stallone to the city. The statue rests at the base of the Philadelphia Museum of Art and has become a shrine for Rocky film fans the world over.

Although he is not technically a Philadelphian, the Rocky Statue and the Rocky films have put Stallone into the eye and heart of the city. (Courtesy of Jim Talone.)

Janis Dardarus

This Philadelphia actress has starred in episodes of television's *Law and Order*, *Third Watch*, *The Sopranos*, and in the films *The Sixth Sense* and *Party Monster*, among others. A noted stage presence in the city's theater scene, Dardarus almost never disappoints. In an *Actors' Lounge* interview, she said that she acts because she cannot do anything else, but that the first time she read for a play in high school, she did not make the cut because she was too nervous and shy. Dardarus honed her skills at the Bucks County Playhouse in New Hope, where she says she "became more comfortable." She thinks of herself as a nonmainstream player and hopes that in the future she can play a variety of roles that do not include being a ninety-year-old woman. "I do wish there was a role that would somehow not put women of a certain age in a certain category . . . that has more voice, sexuality and intelligence." She also believes that, for her, there is no such thing as "tuning out an audience." While on stage, she says that she is "always listening to the audience." (Courtesy of the Wilma Theater.)

Carol Saline

Carol Saline, a widely published writer, broadcaster, medical journalist and public speaker, is the author of eight books. Her best-selling books with photographer Sharon J. Wohlmuth brought her into the national limelight. *Sisters* sold one million copies and spent 63 weeks on the *New York Times* bestseller list. *Mothers and Daughters*, also a bestseller, was followed by *Best Friends*. Beside her published works, which also include *Dr. Snow: How the FBI Nailed an Ivy League Coke King*, she is noted for her stories in the pages of *Philadelphia Magazine* and for her mesmerizing conversational style at parties and public events. (Courtesy of Carol Saline.)

Dito Van Reigersberg

Dito Van Reigersberg is the founder of Pig Iron Theatre Company and the recipient of many awards, including an Obie and several Barrymore Awards from the Philadelphia Theatre Alliance. He is also the originator of the Martha Graham Cracker Cabaret, in which he plays the famous dancer. Reigersberg was born in Georgetown University Hospital and grew up in McLean, Virginia. From the 1990 class of Langley High School, he went to Swarthmore College, outside of Philadelphia, then attended acting school in New York. He told *Philadelphia City Paper* that Pig Iron was at first just a summer gig, but by the third year the group was comfortable in Philadelphia because it seemed like "a cheaper and more practical alternative than New York." (Courtesy of Pig Iron Theatre Company.)

Stu Bykofsky

Stu Bykofsky was named "The Best Columnist in Philadelphia" by *Philadelphia Magazine* in 2011 despite the fact that the former New Yorker had only come to the city in the late 1980s. Often controversial in his opinions, Bykofsky has a thick hide that protects him when it comes to ruffling feathers, especially in the area of political correctness and bicycle-on-the-sidewalk issues. A columnist for the *Philadelphia Daily News* since 1987, he got people thinking (and complaining) in 2007 when he wrote that "to save America, we need another 9/11." Bykofsky went on to write, "What kind of sick bastard would write such a thing? A bastard so sick of how splintered we are politically—thanks mainly to our ineptitude in Iraq—that we have forgotten who the enemy is." Other Bykofsky column titles include "Another Man Killed in Philly for Nothing," and "Release the JFK Records Now!" (Courtesy of Stu Bykofsky.)

Bobbie Booker
This urban-culture observer and adventurer had her start in 1981 when she took on the mantle of beat writer, listener, photographer, lifestyle-issue writer, and pop-culture explorer. Known as "BB" in some circles, her commentary on race, social issues, and music have appeared in nearly every publication in the city, including the *Philadelphia Tribune*. Fellow writers seek out BB's company at press events both large and small. Bobbie, a polymath in her own right, also hosts a Spirit Soul Music Show on Ovations on WRTI-90.1 FM in the city. (Courtesy of Bobbie Booker.)

Perry Milou

Is Philadelphia pop artist Perry Milou the next Andy Warhol? As artists go, the son of Philadelphia restaurateur Neil Stein has probably never starved in a loft. This graduate of the University of Arizona began painting in the first grade, with some in his family circle calling him a "crayon visionary." Milou calls himself a "people's artist" and describes his work as "in your face with vibrant colors." Milou's sock-it-to-you, audacious work includes a huge Liz Taylor, a heavily bejeweled Marilyn Monroe, a strikingly beautiful Frida Kahlo, a remarkable, full-faced, and very distressed-looking Geronimo, as well as a few large iconic portraits of characters from television's *The Sopranos.* The Leroy Neiman–like sports paintings catch viewers off guard, as do the kitschy but powerful Yo Philly Rocky icon portraits. His beautiful paintings of Venice's St. Mark's are large, golden, sun-drenched, impressionistic images of the cathedral that seem to bleed off the canvas. Milou's long list of patrons for commissioned works includes Sylvester Stallone, the Philadelphia Museum of Art, Julius Erving, the Dallas Cowboys, and H. Chase Lenfest. (Courtesy of Perry Milou.)

Blanka Zizka

Blanka Zizka, also known as Philadelphia's theatrical wunderkind, traveled to Philadelphia from Czechoslovakia with husband Jiri Zizka (1953–2012) to help establish the Wilma Project (1973), an avant-garde alternative to the city's then staid theater scene. With an emphasis on original material and homegrown playwrights, the Wilma soon grew into a nationally recognized powerhouse, moving from a small theater location on Sansom Street to a 296-seat megatheater on South Broad Street. After assuming artistic leadership of the Wilma in 1981, the Zizkas solidified the theater's reputation with productions of works by Brecht, Ionesco, Orton, and Tom Stoppard. (Courtesy of the Wilma Theater.)

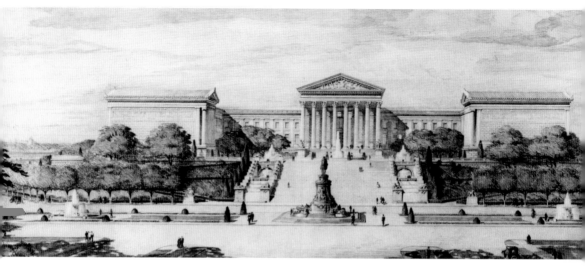

Henry McIlhenny

At 1914 Rittenhouse Square lived Henry McIlhenny, son of Henry Dexter McIlhenny Sr. and Frances McIlhenny, a blueblood Philadelphian who rubbed shoulders with the city's elite class. While at Harvard, McIlhenny decorated his rooms with drawings by Seurat and Matisse; he later collected paintings by David, Ingres, Cézanne, Renoir, Degas, Toulouse-Lautrec, and Picasso. He purchased his family's 1914 town house in 1951 and soon devoted all his time to collecting. He became the chairman of the Philadelphia Art Museum, pictured during construction. "Never did it occur to him to live in any other city than the one in which he had been brought up," writes James Lord in his memoir, *A Gift for Admiration* (1998). "Nor did it ever occur to him that he need be assiduously secretive about the reason which made it unthinkable that he should marry. If people knew [about his sexuality]—and everybody did—they were welcome to take it amiss, but when he gave parties for Princess Margaret, Brooke Astor, or Tennessee Williams, they set aside prejudice and hurried to attend if invited." McIlhenny was a member of the curatorial staff of the Philadelphia Museum of Art in the Department of Decorative Arts. In order to keep good relations with Philadelphia society, he put his Greek lover, Aleco, in an apartment in New York. Members of Philadelphia society knew of this relationship but did not want it rubbed in their faces. McIlhenny acquiesced, and trouble was avoided. Andy Warhol once said that McIlhenny was "the only person in Philadelphia with glamour." (Above, courtesy of Philadelphia Museum of Art; opposite, author's collection.)

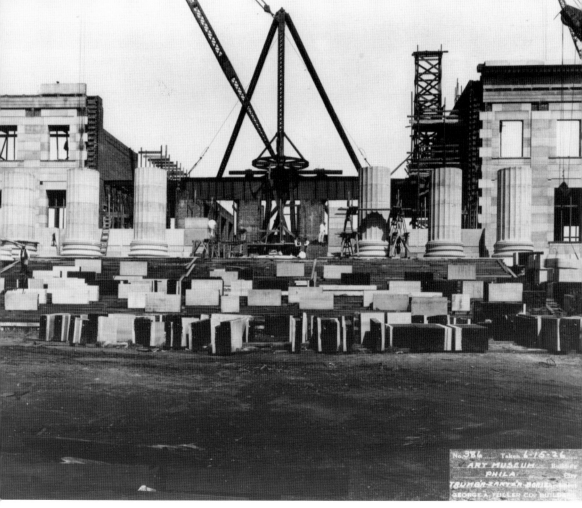

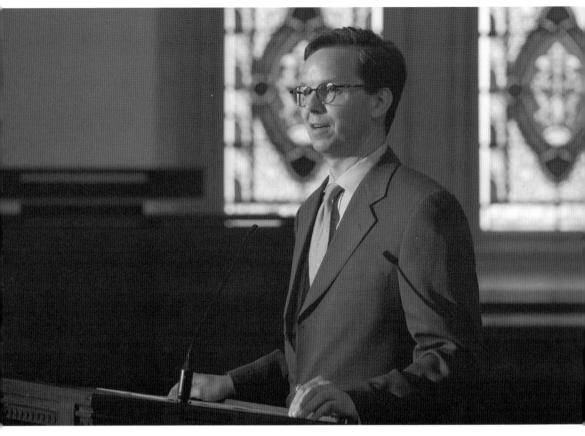

Derick Dreher

This Fulbright scholar and graduate of Yale and Princeton has been the director of Philadelphia's Rosenbach Museum & Library since 1998. Located on Delancey Place, the Rosenbach's collection of rare books, fine art and archival materials dates back to the personal library of brothers Dr. A.S.W. Rosenbach and Philip Rosenbach. An international speaker on rare books, drawings and libraries, Dreher also oversees the Museum's annual Bloomsday celebration (June 17), an all day public reading from James Joyce's *Ulysses*. In 2013, Dreher helped solidify the merger of the Rosenbach with the Free Library of Philadelphia, leading to the creation of The Rosenbach of the Free Library of Philadelphia Foundation. (Above, courtesy of Derick Dreher; opposite, courtesy of the Rosenbach Museum and Library.)

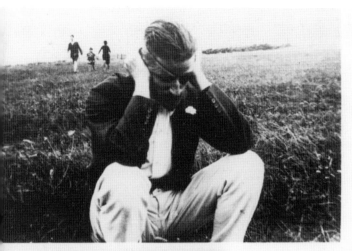

Ulysses in Hand:
The Rosenbach Manuscript

May 1 through August 11, 2002

An exhibition at the Rosenbach Museum & Library, Philadelphia
www.rosenbach.org
Contact: Jennifer Schnabel, 215.732.1600, ext. 126

Top Left: James Joyce (n.d., possibly south of France, 1922).
Collection Rosenbach Museum & Library.

Top Right: Dr. A.S.W. Rosenbach, Book Dealer and Collector.
Collection Rosenbach Museum & Library.

Lower Left: James Joyce. *Ulysses,* author's Ms [Rosenbach Manuscript].
"Stately, plump Buck Mulligan . . ." The first page of the manuscript,
November 1917. Image copyright Rosenbach Museum & Library,
rights to all manuscript material reserved by the literary trustees of the
James Joyce Estate.

Christopher Bartlett
Well known in the city as the current executive director of the William Way Community Center. A graduate of Brown University and New College, Oxford, Bartlett's friendly managerial (and intergenerational) style have won him friends and allies of all ages, beginning from his early days in ACT UP Philadelphia and continuing through his leadership role in Safe Guards, the Gay Men's Health Project, and his creation of the Gay Men's Health Leadership Academy. In 2008, *Instinct Magazine* named him "one of the leading men of 2008." His work at the William Way Community Center includes a heavy commitment to housing for LGBT seniors. His dynamic speaking abilities have also captivated audiences for a number of years. (Courtesy of Christopher Bartlett.)

Elizabeth Osborne

Elizabeth Osborne, often referred to as the "Grand Dame of Philadelphia artists," is the winner of numerous awards, including the Percy M. Owens Memorial Award, a MacDowell Colony Grant, the Richard and Hinda Rosenthal Foundation Award (American Academy and Institute of Arts and Letters), and a Fulbright Fellowship. The University of Pennsylvania graduate went onto the Pennsylvania Academy of the Fine Arts before painting in Paris for a year. Her 40-year body of work is noted for its perfect balance between abstraction and realism. Her art is included in permanent collections at the Philadelphia Museum of Art, the Pennsylvania Academy of Art, the Woodmere Art Museum, and the McNay Art Museum, San Antonio, Texas. (Courtesy of Elizabeth Osborne.)

Bill Scott

Bill Scott, a Philadelphia Center City abstract painter, was born in Bryn Mawr and educated in Quaker schools. His first ambition was to be an art historian, but he later enrolled in the Pennsylvania Academy of the Fine Arts (PAFA). He once told an interviewer that, although he was a graduate of PAFA, his non-PAFA training was the most crucial part of his education. Scott cites two major influences: Philadelphia artists Jane Piper (1916–1991) and Joan Mitchell (1926–1992). The Hallis Taggart Galleries on New York's Upper East Side wrote that Scott's "vibrant paintings lie within the aesthetic continuum of the Philadelphia colorist tradition," a tradition that was passed on to him through both Piper and Mitchell. Scott's paintings are known for their color, vitality, and robust spirit. Scott, the catalog continues, "is able to fuse his local artistic heritage together with the raw energy embedded in her [Mitchell's] abstractions." (Courtesy of Bill Scott Catalog.)

Bill Scott Process and Continuity

Architecture Voith & Mactavish Architects LLP
Preservation 1616 Walnut Street, 24th floor
Planning Philadelphia, PA 19103
Landscape phone 215 545 4544, fax 215 545 3299
Interiors voithandmactavish.com

VMA

VMA

structure, purpose, and beauty:
twenty years

Please join us for the opening
an exhibit of our work.

The Athenaeum of Philadelphia
219 South 6th Street
Philadelphia

RSVP to Chantel Flynn
215-545-4544
or flynn@vma1.com

Friday, February 20, 2009
Gallery opening: 5 – 7 PM
Gallery talk: 5:30 PM *sharp*
Catalog release

Wine and hors d'oeuvres

Daniela Holt Voith

Daniela Holt Voith is the cofounder of Voith & MacTavish Architects (VMA), which celebrated its 20th anniversary in 2009 with a special exhibition at the Athenaeum of Philadelphia. VMA is famous for the diversity of its projects, combining some attributes of modernism with the smarter mainstays of tradition. VMA has designed schools, religious buildings, private homes, and performing arts centers. Voith, a Yale School of Architecture graduate, was named to Mayor Michael Nutter's City Zoning Code Commission. (Courtesy of Voith Mactavish Architects, LLP.)

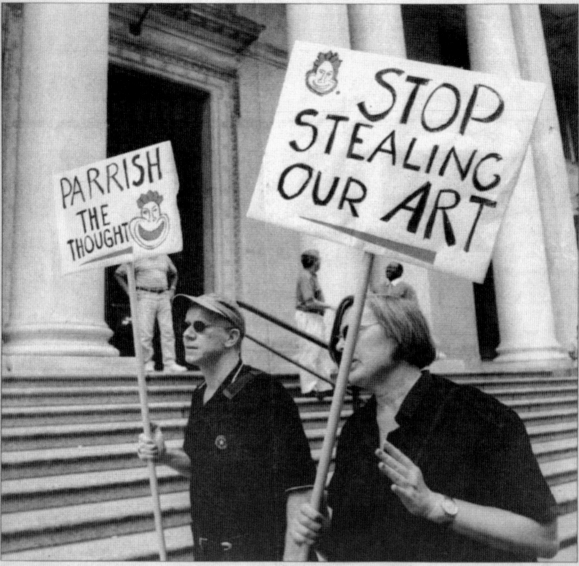

The Philadelphia Inquirer / PETER TOBIA

Thom Nickels and Maevernon Varnum protest the sale of the mural "Dream Garden," which has graced the lobby of the Curtis Center off Independence Square for eight decades. An anonymous buyer wants to dismantle it and ship it out of town. Nickels and Varnum plan to picket tomorrow and Friday. They have set up the Art Defense League, 215-546-6924, hoping to find a way to keep the mural where it is.

Thom Nickels and Maevernon Varnum

In 1998, the owner of Maxfield Parrish's iconic Dream Garden offered to sell it, sparking a grassroots effort to keep the mural in Philadelphia. Author Thom Nickels and Maevernon Varnum founded the Arts Defense League and organized weekly art and petition-gathering demonstrations in front of the Curtis Building in Washington Square, where the mural is located. Related press coverage surrounding this event sparked a city-wide response, resulting in a resolution from the mayor's office that helped keep the piece in the city. (Courtesy of the *Philadelphia Inquirer*.)

Gersil N. Kay

This graduate of the Wharton School of Finance at the University of Pennsylvania is president of the Conservation Lighting Institute and the Building Conservation Institute of Philadelphia. An expert on lighting in businesses and residences, Kay maintains that "contrary to erroneous opinion, lighting design is an art and a science—not a do-it-yourself activity. Only an experienced professional can keep up with all the unexpected variables and the almost daily technological changes. Doing without the right lighting designer—thinking to save a fee—is asking for heavy cost overruns, untold aggravation and possible irreversible damage that would void the financial benefits expected." (Courtesy of Gersil N. Kay.)

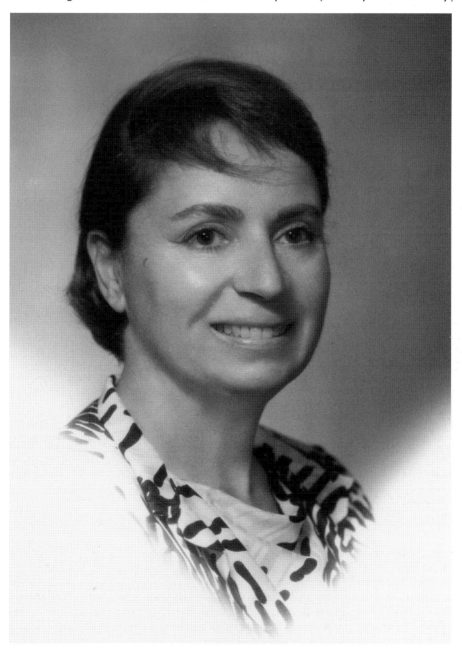

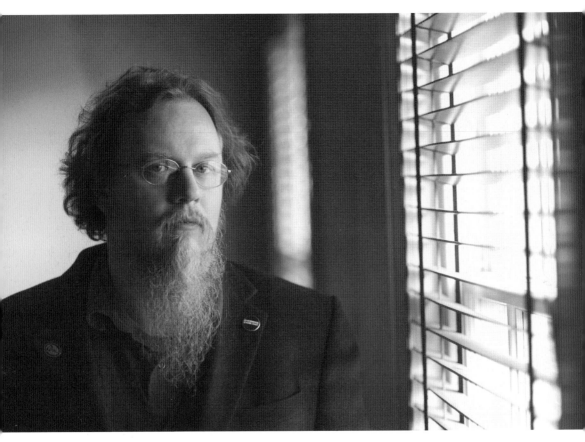

Edward G. Pettit

Edward G. Pettit ("the Poe Guy") grew up in the Olney section of the city but came to the attention of book lovers everywhere when he wrote a piece for *Philadelphia City Paper* proposing that Edgar Allan Poe should be buried in Philadelphia, not Baltimore. The proposal sparked a lot of controversy and even led to a much-publicized public debate (covered by the *New York Times* and NPR) between Pettit, a writer, book reviewer, and college professor at La Salle University, and Jeff Jerome, curator of the Baltimore Edgar Allan Poe House & Museum. (Courtesy of Kyle Cassidy.)

Larry Robin

Larry Robin, owner of Robin's Books (with locations at North and South Thirteenth Street), created a melting-pot space for the city's bohemian and divergent political communities, drawing from Students for a Democratic Society (SDS), the Black Panthers, zany poets, radical feminists, anarchists, and gay activists. Both stores were a bit of early Greenwich Village condensed into a small space, a beacon in the city where so many of the existing bookstores played it safe. In the center of it all was Larry Robin, Philadelphia's unofficial arts and culture guru, who (along with business partner Paul Hogan) steered both stores into the Amazon.com bookstore-killing age. Today, Robin and Hogan operate Moonstone Arts, a think tank reading and coffeehouse venue for writers, poets, and philosophers. (Above and center courtesy of Larry Robin; below, courtesy of Gregory Walker.)

Greg Gillespie

Greg Gillespie, pictured on the right, opened Port Richmond Books in 2004. "We have pretty much everything here," Greg said, "a lot of it is from my personal collection, books that I've liked."

Like long-gone city bookstores such as William H. Allen Books and O'Leary's, Port Richmond Books has an excellent selection of titles. Where else can one find an old hardcover Mary McCarthy novel; the works of Theodore Dreiser, Jack London, Ben Hecht; or first editions of Faulkner, Fitzgerald, Steinbeck, or Kerouac?

With over 200,000 books, the store features a theology section, an American Civil War and military-history area, as well as books devoted to politics, presidential history, railroading, firehouses, and firemen. There are hundreds of literary biographies, travel books, science classics, books on the American West, and New England. There is also an entire room devoted to mysteries.

"We have books on journalism and books on books, on the labor movement, on the '60s counterculture, music, plays, the theater, everything," Gillespie says.

The bookstore also serves as an unofficial community center, with customers and friends dropping in and sharing conversation or an occasional glass of wine. Gillespie's office looks like a room in an old Parisian mansion, with a lounging sofa, antique chairs, and a handsome desk surrounded by leather-bound books. Many author readings and impromptu parties are held here.

On the balcony are many Society Hill Playhouse theater props—such as a human skeleton on a chain and a 19th-century baby carriage—as well as the nearly disintegrated Edison movie posters from when the building was the 1,026-seat Richmond Theater, which opened in 1913. (Author's collection.)

John Dowlin

John Dowlin, or "Papa John" of Powelton Village, was born in Detroit and attended Hamilton College while serving in New York state with the US Air Force. He studied at Goddard College in Vermont, where he met Buddhist poet Paul Reps and anarchist philosopher Murray Bookchin. In the mid-1960s, he moved to New York, where he wrote reviews for *Dance Magazine* and helped to organize national speaking tours for Tran Van Dinh, a former South Vietnam diplomat who resigned in protest as the United States escalated its intervention in Vietnam.

In Philadelphia in 1972, John created the international bicycle "velorutionary" movement. This involved creating the first bicycle map of the city. The now-ubiquitous "u-rack" for bike parking was designed by architect David Rulon with John's consultation. In the early 1970s, John organized "Midnight Bicycle Rides" to enable cyclists to claim the city and build community, and his annual publication, the Cycle and Recycle Calendar, began to attract worldwide attention. The Philadelphia Bicycle Coalition that was founded by John and a small group in the early 1970s eventually evolved into the Bicycle Coalition of Greater Philadelphia, with a staff of 11 and professional offices and budget. (Courtesy of Mary Day Kent and Debbie Dowlin.)

Ed Hermance

Born in Houston, Texas, in 1940, Ed Hermance attended Dartmouth College and Indiana University and then worked as a teacher in the United States and Germany before deciding to leave for Colorado, where he joined a hippie commune that also attracted Allen Ginsberg and Peter Orvlosky. He lived in San Francisco before settling in Philadelphia, where he worked a number of jobs before becoming co-owner of Giovanni's Room, the second-oldest gay and lesbian bookstore in the country after the (now-defunct) Oscar Wilde Memorial Bookstore in New York City. Giovanni's Room first opened on South Street in 1979, then moved to Spruce Street for three years before the landlord, fearing that a gay bookstore would attract too many homosexuals, forced Hermance to find new quarters. Hermance and co-owner Arlene Olshan bought a building on the corner of Twelfth and Pine Streets and engaged the community to help them do renovations. Giovanni's Room is now the oldest continuously running LGBT bookstore in the country. (Courtesy of Giovanni's Room.)

CHAPTER THREE

Today's Athletes, Businesspersons, and Spiritual Warriors

Philadelphia has a rich religious and spiritual tradition. Orthodox Christian clergymen, such as Fr. Mark Shinn of Saint Andrew's Russian Orthodox Cathedral, or the Very Reverend Alexis P. Gouguin of St. Nicholas Eastern Orthodox Church, have helped to keep ancient Christians traditions alive in Philadelphia. On the Catholic side, Fr. John McNamee, the pastor emeritus of St. Malachy Church in North Philadelphia, has been in the vanguard of organizing social programs for the poor. The first Catholic community in Philadelphia was established at Old St. Joseph's Church in 1733 by English Jesuits who first arrived in Maryland in 1634. There were Jewish traders in the region sometime before the arrival of William Penn; by 1734, there were several Jewish families residing in the city. Congregation Mikrieh Israel, founded in 1745, was the city's first synagogue.

Frank Brancaccio

Frank Brancaccio, who lived in New York City during the Andy Warhol Factory years, studied acting with Stella Adler and became an assistant editor for *After Dark* magazine. For years, he was a popular regular on Dick Clark's *American Bandstand*, where he danced with Arlene Dipitro and others. His autobiographical novel, *Ephemeral Nights*, was published in 2004. About his *Bandstand* years, Frank recalls, "I went to *Bandstand* and became a popular regular from the age of 14 to 17. It was very weird being famous for having no real talent except for being on a live show everyday and just dancing by a camera and being on TV. You realized the fame you had when you visited other cities and saw how people responded to you. I mean if I was someone else, I wouldn't want my autograph, but others did. It was fun at the time!"

With his 1960s Ricky Nelson–style good looks, it is hard to think of Frank Brancaccio as ever being a misfit, but in the 1950s, if a boy did not want to play baseball, people thought there was something wrong. Frank is on record as telling a number of journalists that most of the good-looking (and masculine) *American Bandstand* male regulars were not straight. Dick Clark had three rules for dancers: no camera hogs; no close dancing, and no dancing with someone of a different color. To filter out the show's gays, Clark sent spies to Rittenhouse Square to see if any of the male regulars were conjuring lavender spirits. Frank, who regularly hung out in the square, survived the witch hunt and says it was probably because Clark liked him and never suspected that a macho South Philly kid could be gay. (Both, courtesy of Frank Brancaccio.)

Ray Duval

Ray Duval, an iconic figure in the Philadelphia theater world, was born in 1938 as Nathan Goldiner. In college, he wrote and directed plays. Later, he served as a Barrymore nominator for the Philadelphia Theatre Alliance and house manager for Philadelphia's Prince Theater. Duval had a distinctive personal style and would greet his many friends at city theaters like the Wilma, the Philadelphia International Film Festival, the Philadelphia Fringe Festival, and the Suzanne Roberts Theater with a hug and a kiss. He produced an independent film and appeared in four independent films in addition to writing his own entertainment column for *Nicetown News*. He was called "Philadelphia's greatest theater advocate" after his death in October 2013. At his memorial service in the Prince Theater, Michael LeLand, artistic director of Theatre Double, sang "I've got a right to sing the blues," reducing many audience members to tears. (Courtesy of Aaron Ron Hunter.)

Robert and Claudia Christian
Robert and Claudia Christian, have been in the newspaper-publishing business since 1988. Robert originally came to Philadelphia from New York, where he intended to resume his studies as an Anglican seminarian but says that his goals changed when he discovered desktop publishing. A descendant of circus showman P.T. Barnum (who published a newspaper in Danbury, Connecticut in the 1820s) Robert says, "In a fit of madness we started a free paper." The small Christian empire began with the *University City Review* in 1988 and the *Weekly Press* (serving Center City) in 1990. "We give people a sense of place," Robert likes to say. Many *Weekly/UC Press* stories have been picked up by larger media outlets and repackaged as breaking news, a testament to the Christians' sharp nose for news. (Courtesy of Jim Talone.)

Julie Morris Disston
Julie Morris Disston is a member of one of Philadelphia's oldest families (a line going back to 1685 when Anthony Morris was mayor of the city). Her grandfather Effingham B. Morris (1856–1937), president of the Girard Trust Company for 41 years and a one-time director of the Pennsylvania Railroad, was a noted financier and civic leader. Her father, Effingham B. Jr., was a lawyer who went into banking. He married Julia Peabody Lewis, who died in 1938 at age 47 when, according to *Time Magazine*, "a horse she was riding caught its knees on a fence in mid-jump [and] somersaulted into her." (Author's collection.)

Arnold Thackray
Arnold Thackray, founder of Philadelphia's illustrious Chemical Heritage Foundation, an organization dedicated to the history and philosophy of science and chemistry, was born in northwest England in 1939. Educated at Leeds University and Cambridge, he earned a master of arts and a PhD in the history of science and later taught at Oxford and the London School of Economics. He moved to the United States in 1967, becoming a citizen in 1981. He is the recipient of the Dexter Award from the American Chemical Society for outstanding contributions to the history of chemistry. The Chemical Heritage Foundation's world-class collection attracts scholars and scientists throughout the world. (Courtesy of Chemical Heritage Foundation.)

Judy Wicks

Judy Wicks arrived in Philadelphia in 1970 with a vision to start the city's first Free People's Store, a countercultural outlet that later became the wildly successful Urban Outfitters. Wanting to expand her horizons, in 1983, she started the White Dog Café on the first floor of her home in University City. The White Dog later expanded into an iconic destination for intellectuals, artists, and urban sophisticates. "At first I simply wanted a cozy place with tasty, healthy local food where I could hang out with my friends and neighbors," Judy says. "But as time went on, I saw that my true profession was using good food and fun to lure innocent customers into social activism!" The story of Philadelphia's best-known entrepreneur can be found in her 2013 memoir, *Good Morning, Beautiful Business: The Unexpected Journey of an Activist Entrepreneur and Local Economy Person.* (Courtesy of Judy Wicks.)

Nicole Cashman

Cashman & Associates Public Relations has set an indelible mark on the city with its high-profile, highly stylized events. Founder Nicole, a graduate of Drexel University, developed her public relations skills in New York City as Bloomingdale's director of public relations. She then headed back to Philadelphia to work for the mammoth three-state Strawbridge store chain until she started her boutique public relations business in 1999. One year after her company's promotion of the 2000 Republican National Convention, Nicole founded Cashman & Associates, becoming both the organization's president and chief executive officer. Since that time, success has been an uninterrupted stairway to heaven. Not only does Cashman seem to run the best events in the city, but "the Cashman touch" is known for its own iconic brand of hospitality and grace. Nicole Cashman has received Drexel University's Rankin-Epstein Distinguished Alumni Award, Philadelphia Business Journal's Women of Distinction Award, the Special Achievement Award in Business from the National Italian American Political Action Committee, and the Gift of Life Donor Program's Hero of the Year Award. (Courtesy of Nicole Cashman.)

Nessa Forman

Nessa Forman, coauthor of *Woofs to the Wise: Learning to Lick at Life and Chew on Civility* and vice president of Corporate Communications and Public Affairs at WHYY, Inc. (1983–2007), was a pioneer in Philadelphia journalism when, in the late 1960s, she supervised a composing room full of men at the *Evening Bulletin*. By the time she left the *Bulletin* in 1982, she was Arts & Leisure editor. At WHYY, Inc., she developed an effective early promotional campaign for Terry Gross's *Fresh Air*. Noted for her "caring ways" and "kindheartedness," she early on established a reputation of having a talent for maintaining friendships with a wide variety of people. One of her favorite ways of building community was taking people to lunch. Born in Atlantic City, New Jersey, she was University of Pennsylvania educated. In 2002, she was named to the Philadelphia Public Relations Association Hall of Fame, and in 2005, the Philadelphia Business Journal named her a woman of distinction. Her death in 2011 was met with considerable sadness. (Courtesy of WHYY, Inc.)

Joe Vandergast

Joe Vandergast was part of the best film crew in Philadelphia as documentary cameraman for KYW-TV (1970–1980). After KYW, he went on to work as a cinematographer for Marki Films, helping to create the critically acclaimed *Stone Reader* (based on the book *The Stones of Summer*), a powerful series of author interviews. Subjects included Frank Conroy, author of the perennial American classic *Stop-Time*. Vandergast began his documentary-film career at H.G. Peters Studio and hit a comfortable stride at KYW when he went to Senegal, Africa, with reporter Malcolm Poindexter in 1977 to document the reactions of 24 black Americans visiting Senegal slave houses and the historic slave auction blocks written about in Alex Haley's *Roots*. At KYW, Vandergast became a close friend and confident of Jessica Savitch. He was also the cinematographer for the 1976 documentary *Jimmy Who: Jimmy Carter 1976*, a film that follows Carter on the campaign trail while he was still relatively unknown. (Courtesy of Joe Vandergast.)

Jessica Savitch

Jessica Savitch grew up in Kennet Square, Pennsylvania, and went on to become a trailblazer for women in broadcasting. While a student at Ithaca College in upstate New York, she was once told by a faculty advisor that "there's no place for broads in broadcasting." Undeterred, she was hired by KHOU-TV in Houston, where she boosted ratings. In 1972, Philadelphia came calling, and she was hired by KYW-TV to co-anchor the local news with Mort Crim (pictured), moving KYW-TV's ratings to No. 1. Savitch was hired by NBC in 1977, where she covered the US Senate and anchored the Sunday-evening news. Later, she would anchor the daily news before her tragic death on October 23, 1983, in New Hope, Pennsylvania. After a dinner out at Chez Odette restaurant near New Hope's Delaware River canal, the driver of her car, boyfriend Martin Fischnein, took a wrong turn. The car flipped into the waterway, and both Savitch and Fischnein were killed. Crim later told reporters that Jessica "attracted tragedy like a magnet." (Courtesy of Joe Vandergast.)

Juanita Sims

Juanita Sims (1928–1979) was America's first African American saleswoman for the Ford Motor Company. Described by her photojournalist/artist daughter Phyllis Sims as a "person who became a powerhouse woman," Juanita first worked as a barmaid for a number of clubs in Philadelphia, New York, Baltimore, and Washington, DC. Later in life, Juanita and husband Poogie opened a popular record shop at 1713 Federal Street. The shop attracted traveling bands like the Mills Brothers, who would come and visit after concerts. The shop's basement speakeasy was also a popular destination. (Courtesy of Phyllis Sims.)

Terry Gross
Terry Gross, one of the nation's finest radio interviewers, was born in Brooklyn, New York, and educated at the University of Buffalo before she began working as a teacher. Unsuccessful in that field (she was fired shortly after being hired), she began her public-radio career with a stint at Buffalo's WBFO in 1973. Two years later, Gross moved to Philadelphia to host and produce *Fresh Air*, then a local broadcast at WHYY-FM. At that time, Gross also hosted a music-based radio show in which listeners talked about their favorite popular and jazz LPs, which were played on the air. *Fresh Air* went national in 1985. Although Gross's style is perceived as relaxed and casual, Lou Reed once walked out of an interview. Gross defended herself to a reporter: "I think he was in a cranky mood." She later added, "I try not to argue with my guests. If someone is being crude, obnoxious, or insulting to me, I don't take it personally." (Courtesy of WHYY-FM.)

Marty Moss-Coane

Marjorie S. "Marty" Moss-Coane, was born on Valentine's Day 1949. The host and executive producer of *Radio Times With Marty Moss-Coane* in Philadelphia, started as a volunteer at Philadelphia's WHYY-FM studios in 1983. From her role as associate producer of Terry Gross's *Fresh Air*, she became the host of her own local show (*Radio Times*) when Gross went national in 1987. Moss-Coane and *Radio Times* have won numerous awards, such as the 2002 *Business Journal*'s Woman of Distinction Award and *Philadelphia Magazine*'s two times designation of *Radio Times* as Best Radio Talk Show Host. Moss-Coane says that in the beginning of her career, she was "terrified of making a mistake, of sounding like a fool, of not being as good as Terry Gross." In another interview, she talked of her radio guests, saying, "We've had lousy guests—the lousy guests are ponderous talkers. We've had hostile guests; we've had guests who were drunk or high. We had one guy who was as high as a kite. The truth is, that's the rare guest. Most of them are pretty good and we're pretty choosy who we have on." (Courtesy of WHYY-FM.)

Richie Ashburn

Richie Ashburn Jr. is pictured here. His father, Richie Ashburn, one of the most beloved sports figures in Philadelphia, was born in 1927 in Nebraska. The iconic center fielder, who would be inducted into the National Baseball Hall of Fame in 1995, spent 12 of his 15 major-league seasons with the Philadelphia Phillies. Nicknamed "Putt Putt" by baseball great Ted Williams because he "ran so fast you would think he had twin motors in his pants," Ashburn often slept with his bat because he did not trust league handlers to give him the same one when practice and the games resumed. The last year of his baseball life was spent with the New York Mets. Although "Putt Putt" had an excellent batting average, he could not save a losing team, so he retired at the end of the 1962 season. The following year saw him working as the radio/television commentator for the Phillies and as a writer for the *Philadelphia Bulletin* and the *Philadelphia Daily News*. Philadelphia's favorite son died of a heart attack in 1997 in New York after broadcasting a Phillies-Mets game from Shea Stadium. (Courtesy of Richie Ashburn Jr.)

Michael Jack Schmidt

Michael Jack Schmidt, a 12-time All-Star Phillies third baseman who won 10 Gold Gloves and was named the Sporting News Player of the Decade for the 1980s, had a rock star's charisma when he made his Phillies debut in 1972 at age 22. Screaming fans, especially girls, had an over-the-top reaction to his golden-boy good looks and athletic stamina. Schmidt, who was born in 1949, holds the Major League record for a third baseman for making 48 homeruns in 1980. Inducted into the Baseball Hall of Fame in 1995, Schmidt showed great humility when he told the assembly, "You know, life for me was not always baseball, there was God, family, and there were real people, guys who come on once in a lifetime, a guy who I will always consider my closest friend from baseball, Gary Maddox . . . Along with Gary, and the counseling of Wendell Kempten, Andre Thornton, Pat Williams, I found and committed my life to what is the real foundation for living—Jesus Christ." (Courtesy of Jacocks Collectibles.)

Connie Mack

Connie Mack (December 22, 1862–February 8, 1956) was born Cornelius McGillicuddy Sr. to Irish immigrants in Massachusetts; he later become known as Connie Mack, or Mr. Mack, when he managed the Philadelphia Athletics beginning in 1901. He retired at age 87 after the 1950 season. Although he failed to distinguish himself as a baseball player, as the longest-serving manager in Major League Baseball history, he achieved legendary status. He was the first manager to win the World Series three times. Known as a quiet gentleman with a tranquil managerial style, Mr. Mack imposed no curfews on his players but was known for his personal generosity, such as when he would come to the rescue of players in financial difficulty. Mr. Mack looked for players who were self-disciplined in their personal lives. This lifelong observant Catholic made the cover of *Time* in 1927. Five years after his retirement, the Athletics were sold to Kansas City, making the Phillies the only baseball team in the city. Philadelphia's baseball stadium, Shibe Park, was renamed Connie Mack Stadium in 1953. Mr. Mack died peacefully in his daughter Margaret's Cliveden Avenue Germantown home. (Courtesy of Jacocks Collectibles.)

To thom - Best always Ruth Williams Heverly

Ruth Williams Heverly
All-American Girls Professional Baseball League
Honorary Celebrity Co-Chairman, 1993 Midland Run

Ruth Williams Heverly

Ruth Williams Heverly was born in Nescopeck, Pennsylvania, in 1926. She began her baseball career at 20 years old, although the sport had attracted her at age 12. She was a pitcher and played for two teams, the Kalamazoo Lassies and the South Bend Blue Sox, as part of the All-American Girls Professional Baseball League (AAGPBL). When she tried out for the league, she was selected among a pool of 400 girls. A graduate of East Stroudsburg University, she went on to teach at Wissakickon High School in Ambler, Pennsylvania. The AAGPBL, started in 1943 by Chicago Cubs owner Phillip K. Wrigley, was the inspiration behind the Hollywood film *A League of Their Own*, starring Tom Hanks, Madonna, and Geena Davis. Before her death in 2005, the *Philadelphia Inquirer* interviewed Heverly, who said of the film, "The baseball just wasn't up to snuff. Don't get me wrong, it wasn't bad. But we were better . . . No catcher ever caught a pop doing splits (as Geena Davis does). And we never caught a fly ball in our caps. That was Hollywood." The AAGPBL consisted of 556 women and lasted until 1954. Heverly suffered a tragic loss in 1980 when her husband, Leonard, was killed by a drunken driver as he bicycled in Nevada. (Courtesy of Ruth Heverly.)

Lisa Heyman

Lisa Heyman, an imposing fixture in the city's theater world, has attended thousands of plays, operas, dance productions, concerts, and art shows throughout the city. She is known for dressing in black with her long hair under a French beret and for being quick to smile and say hello during countless openings at the Suzanne Roberts, Wilma, and Prince Theaters. Born in Rochester, New York, she became a Philadelphian in 1976 as the first Center City Philadelphia Victim Crime Counselor. That same year, she founded the Center City Temple University Criminal Justice Program, going on to her 34-year career with the Philadelphia Court of Common Pleas as a training specialist and administrator. "I was greatly influenced by my mother, who was a talented, accomplished artist and lover of art and culture," she says. (Courtesy of Lisa Heyman.)

Matthew C. Glandorf

The dynamic artistic director of Choral Arts Philadelphia is a graduate (and a current faculty member) of the Curtis Institute of Music. Born and raised in Germany, he became a conductor, composer, and church musician at a very early age, having studied under Wolfgang Baumgratz at Bremen Cathedral. He had infused new life into the city's music scene as director (since 2008) of the Bach Festival of Philadelphia. Glandorf says that an essential element of his work with Choral Arts Philadelphia "is breaking down the social and economic barriers to broader enjoyment and experience of music—to bring the realization that music transcends all boundaries and nourishes our fundamental hunger for living life to its fullest." (Courtesy of the Choral Arts Society.)

George Crumb
George Crumb (born October 29, 1929), a Pulitzer Prize—winning composer of contemporary classical music, was born in Charleston, West Virginia, and studied music in Berlin and at the University of Michigan. His life as a Philadelphian began with his becoming an Annenberg professor of the humanities at the University of Pennsylvania in 1965. The winner of numerous artistic-achievement awards, Crumb won a 2001 Grammy Award for Best Contemporary Composition. He told a reporter in the 1980s that winning a Pulitzer can only do so much. "If you win the Pulitzer Prize, probably for a couple of years, anyway, people are talking a little more about your music," he said. "It might be reflected for a while in your royalty checks, but I don't think that it probably can influence much your development as a composer in the real sense . . . One should not become obsessed with winning prizes, and in fact as a student I hardly won anything at all; my classmates were winning all kinds of things." (Author's collection.)

Ann Crumb

The daughter of composer George Crumb made her Broadway debut in 1987 with the company of *Les Misérables* and went on to appear in *Chess*, *Aspects of Love*, and *Anna Karenina*, for which she received a Best Actress Tony nomination. She toured in the title role in *Evita* and had roles in *As the World Turns*, *The Guiding Light*, *Another World*, and *Law and Order*.

Her recordings include *A Broadway Diva Swings* with the Harry Allen orchestra, as well as numerous collaborations and recordings with her father, such as her role as lead soprano when she appeared with him at the Kimmel Center in the fall of 2009 on occasional of his 80th birthday.

The *New York Times* once described Ann's singing voice as one that "can harden in a moment from molten to hard steel." In Andrew Lloyd Webber's *Aspects of Love*, Crumb sang the part of sexy French actress Rose Vibert, whose romantic entanglements cover a 17-year period. When she met producer Robert W. Schachner, she recorded *A Broadway Diva Swings* in the Florida Keys. Today, Crumb is easily one of the best female jazz vocalists in the business.

Crumb reflects, "Growing up, I heard all those great singers, but it was different sounds. I didn't sing, I was really a 'straight' actress. Then when I finally heard the CD of *Evita*—the show was just closing on Broadway—I wanted to play her dramatically, so I said I've got to study singing so I can play her."

Study she did. She arranged to be mentored by internationally acclaimed American voice teacher Bill Shuman but says it was a while before she got into the swing of it. "I was too shy about it. I still have a terrible problem with shyness. I still think of myself as an actress, not a singer." (Author's collection.)

Donald Nally

Donald Nally, once referred to as "the choral czar of Philadelphia," was born in Hilltown, Pennsylvania. This conductor and opera chorus master specializes in new music, but he has also worked in the concert world and opera. Nally's road to international recognition began with his work for the Opera Company of Philadelphia, where he was chorus master, the Pennsylvania Ballet, and the Philadelphia Orchestra. For several years, he was the music director for St. Mark's Episcopal Church in Center City. He has worked with Renee Fleming, Gian Carlo Menotti, Peter Sellars, and Placido Domingo. The recipient of numerous musical awards, Nally has left an indelible mark on the city's choral arts music scene. (Courtesy of Choral Arts Society of Philadelphia.)

Mario Lanza

Mario Lanza (1921–1959). The famous opera tenor and Hollywood actor was born in Philadelphia to Italian immigrant parents. He began singing as a teen at the YMCA Philadelphia Opera Productions. Originally named Alfred Arnold Cocozza, he changed his name to Mario Lanza (his mother's maiden name was Lanza) during a musical festival in Tanglewood, Massachusetts, in 1952. His Hollywood career began when Louis B. Mayer signed him to a seven-year contract. The handsome star was featured in many films. Gossip columnist Hedda Hopper, referencing the singer's love of alcohol and food, once wrote: "His smile, which was as big as his voice, was matched with the habits of a tiger cub, impossible to housebreak." (Courtesy of the Mario Lanza Museum.)

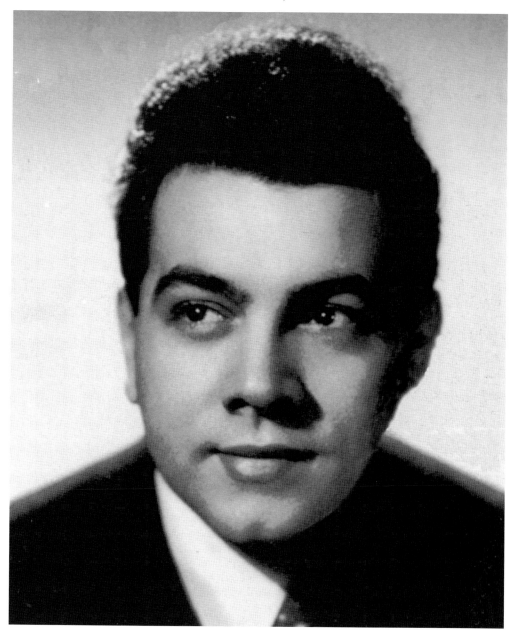

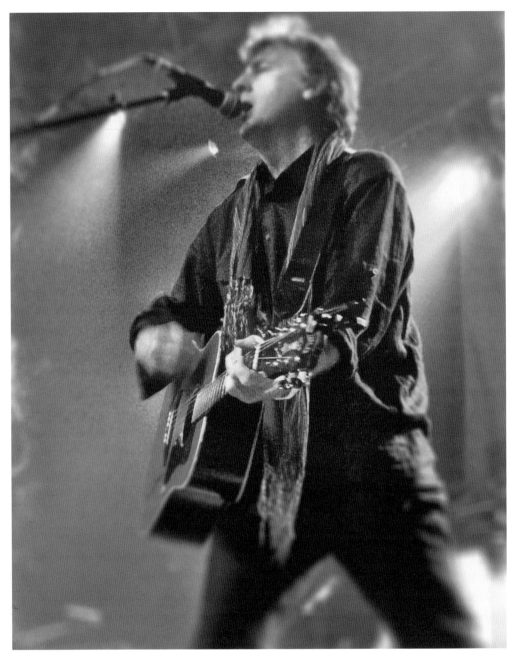

Kenn Kweder
Born in Upper Darby, the folk-rock musician at first wanted to be a basketball player, but he later entered the music world with his first band, Kenn Kweder & the Secret Kidds. The fiercely independent singer-songwriter has been an iconic name in the city since the early 1970s. Noted for his musically diverse styles—his influences range from Leonard Cohen to David Bowie and Lou Reed—he continues to be a vibrant force in the local music scene despite not being better known nationally. Signed to the independent Pandemonium label, Kweder values creative control just as much as national recognition. (Courtesy of Kenn Kweder.)

Stephen Costello

Born in 1981 in Philadelphia's Fishtown neighborhood, Costello graduated from Philadelphia's Academy of Vocal Arts in 2007 but began his professional debut as an operatic tenor in 2006 as Rodolfo in the Fort Worth Opera's production of *La Bohème*. Costello's Metropolitan Opera debut occurred during opening night of the 2007–2008 season when he played Arturo in *Lucia di Lammemoor*. Costello was awarded the Richard Tucker Award in 2009. So far, his rise to early fame as an opera tenor has not attracted the kind of publicity it would have had he been a rock star or famous athlete, although many see him as the next Pavarotti. Costello is married to opera soprano Ailyn Pérez. (Courtesy of Dario Acosta.)

Eugene Ormandy

Born Jeno Blau, the future conductor of the Philadelphia Orchestra and the originator of "the Philadelphia sound," moved to the United States in 1821 and became a US citizen in 1927. Ormandy gave his first performance with the Philadelphia Orchestra in 1931 while still established as the conductor of the New York Philharmonic, a position he gained in 1929. He became associate conductor of the Philadelphia Orchestra in 1936 and two years later was made music director, a position he held for 42 years. Ormandy is responsible for transforming the Philadelphia Orchestra into a world-class institution with a style that was both Romantic and voluptuous. He was knighted by Queen Elizabeth in 1976 and died on March 12, 1985. (Courtesy of Joe Nettis.)

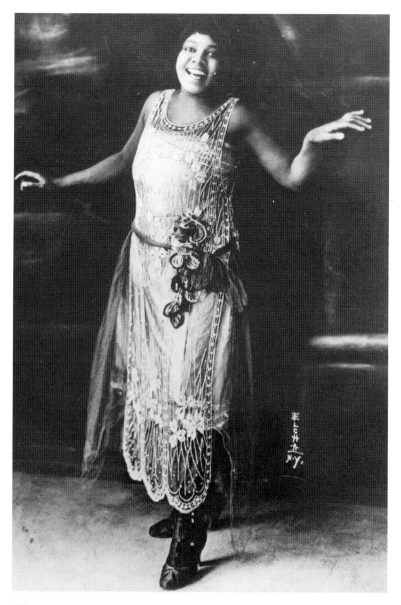

Bessie Smith

Although born in Tennessee in 1898, "the Empress of the Blues" lived for a time on Kater Street in Philadelphia; an association that helped her earn the title "Philadelphia's Favorite Daughter." After her marriage to her second husband, Jack Gee, in 1923, she met Ma Rainey, "the Mother of the Blues." Chris Albertson, author of *Bessie*, writes that Rainey "literally kidnapped Bessie," and that "she and her husband forced the girl to tour with their show, teaching her in the process how to sing the blues." Smith and Gee had a storied relationship, which was complicated by Smith's involvement with several women. Because Columbia Records' line of recordings for African American artists—called "race records—did not consider racy themes or even homosexuality as taboo, Smith was able to write songs such as "Soft Pedal Blues," "The Boy in the Boat," and "Foolish Man Blues." Smith died from injuries resulting from a car crash in Mississippi in 1937 because the closest hospital was "white only" and refused to admit her as a patient. (Courtesy of Phyllis Sims.)

HughE Dillon

When HughE Dillon (right) shows up at a city event with his camera, people pay attention. The 2013 Philadelphia DOGooder Innovation Award and Linda Creek Foundation Award winner founded his private social, political, and lifestyle blog, *Philly Chit Chat*, in 2007 while working as a paralegal. Since that time, no party event, fashion show, restaurant opening, or retail event has been complete without him. Photographing the famous and not so famous for Fox 29 television as an on-the-scene correspondent and for Philly.com and *Philadelphia Magazine*, HughE has an eye for faces and "presence" that has made Philly Chit Chat one of the leading news and entertainment online publications in the city. (Courtesy of Jim Talone.)

H.F. "Gerry" Lenfest

H.F. "Gerry" Lenfest, the son of a naval architect, grew up playing hooky in high school and spent time as a rustic oil-rig worker in North Dakota. After graduating from law school, he went to work for Walter H. Annenberg's Triangle Publications, where he went on to become publisher and editorial director of *Seventeen Magazine*. He started Lenfest Communications in 1974 when he purchased two cable systems from Annenberg. For a number of years, he ran the business from his basement with his wife, Marguerite, while raising three children. After he sold the business in 2000 for $1.2 billion, he quickly became Philadelphia's most famous philanthropist, giving more than $800 million to higher education and to charities. As chairman of the board for the Curtis Institute of Music, Lenfest financed the construction of a new student dorm along the block of 1600 Locust Street. (Courtesy of the Lenfest Center.)

Neal Zoren

If Oscar Wilde had the chance to live today, he might gladly reincarnate into the body of Neal Zoren. The noted theater critic and television writer has entertained audiences for years, both in print for many newspapers—like the *Delaware County Daily Times* and the *Philadelphia Inquirer*, and as a radio and television critic/commentator. Witty, urbane, and always one to pull verbal rabbits out of hats, Zoren has aptly been called a "Zorro of the written word." (Courtesy of Neal Zoren.)

Valerie Morrison

Valerie Morrison, this well-known Philadelphia psychic medium and parapsychologist, has been seeing clients on a professional basis for over 30 years. A registered nurse, Morrison refers to her grandfather as a great psychic along the lines of "another Edgar Cayce." She had her first paranormal experiences as a child and firmly believes that the psychic ability of most children is "trained" out of them by parents and families. Morrison's fiercely independent style is disdainful of channeling, as well as of the notions of spirit guides. She has made hundreds of radio and television appearances and is the winner of numerous awards, including the 1985 Armed Forces Inaugural Committee Award and the Four Chaplains Legion of Honor. (Courtesy of Valerie Morrison.)

Arlene Ostapowizc

Arlene Ostapowizc is a Philadelphia psychic, medium, and astrologer who studied metaphysics in England in 1972. Arlene's predictive abilities are known far and wide thanks to word-of-mouth advertising, though she admits she has never sought fame. People in Philadelphia ask, "Have you had a reading from Arlene yet?" City politicians like Councilwoman Joan Krajewski have consulted her over many years, as have a number of city judges who would send limousines to escort her for readings in their private chambers. For several years, she worked at the *Courier Post of New Jersey* as a consulting psychic, and she served as a monthly psychic commentator on an Atlantic City cable television in addition to making radio guest appearances. She once turned down an offer to appear on Bill Maher's *Politically Incorrect* because of the show's late hours. When Frank Rizzo ran for a third term as mayor, he told her, "If I get elected, I'm going to get you an office in City Hall and put you on the payroll." She has worked with the Philadelphia police on many crimes, such as the Dolores Della Penna murder in 1972 and the Candace Clothier killing in 1968. A devout Catholic, Arlene tells religious fundamentalists that what she does is God's work and that authentic mediumship goes back in the Bible from Moses and the burning bush to St. Thomas the Apostle, "who was the medium among the 12 Apostles." (Author's collection.)

Mother Divine

Philadelphia's Father Divine married his second wife, 21-year-old Edna Rose Ritchings, a white Canadian, in 1946. Their marriage was a celibate union, as members of the Peace Mission Movement, both married and single, are required to refrain from sex, alcohol, and tobacco.

When Father Divine died in 1965, Mother Divine became the spiritual leader of the movement. She is pictured here with the author.

The Peace Mission Movement began as a force for peace and goodwill between the races, as an incentive to make people—as Mother Divine notes in her small book, *The Peace Mission Movement*—"industrious, independent, tax-paying citizens instead of consumers of tax dollars on the welfare rolls."

Father Divine's greatest contributions are probably in the area of civil rights. As early as 1951, he advocated for reparations for the descendants of slaves and for integrated neighborhoods. Decades before the Civil Rights Act, before the NAACP, before Stokley Carmichael, Angela Davis, or the Black Panthers, Father Divine preached peaceful, nonviolent social change. Unfortunately, Father Divine's "preaching" work on behalf of civil rights is a mostly understated fact.

In 1972, sometime after Father Divine's death, Mother Divine issued the Rev. Jim Jones and his followers, who had come to the Woodmont Peace Mission estate, their marching orders. Mother Divine ordered Jones to leave the estate after Jones attempted to take over the movement, claiming that he was the reincarnation of Father Divine. Some 200 of Jones's followers had arrived from California, "pretending," as Mother states, "a sincere desire to fellowship with members of the Movement."

Mother asked them to leave when "his distaste for the government of the United States and the establishment, and the prosperity of the followers in general, began to be expressed in casual, then more deliberate remarks he made to Mother Divine and others."

Several years later would come the insanity of the People's Temple in Guyana. (Author's collection.)

Judith Tannenbaum

Judith Tannenbaum was forced into the limelight in 1988 when, as the unofficial acting director of the Philadelphia Institute for Contemporary Art, she handled the controversy surrounding an exhibit of Robert Mapplethorpe's work, *The Perfect Moment*. Although the show was popular in Philadelphia and Chicago, because of the show's erotic content, political forces caused its cancellation at the Corcoran in Washington, D.C. Robin Rice, art critic for *Philadelphia City Paper*, wrote that Tannenbaum's bravery in the face of so much right-wing backlash helped establish a rare, rational balance. Tannenbaum's "steadfast demeanor during a long siege," Rice commented, "stood in dignified contrast to hysterical rantings on all sides and won her admirers throughout the art community." Tannenbaum was named the Rhode Island School of Design's first curator of contemporary art in 2000, and since that time she has organized many interdisciplinary exhibitions of painting, sculpture, and video. (Courtesy of Judith Tannenbaum.)

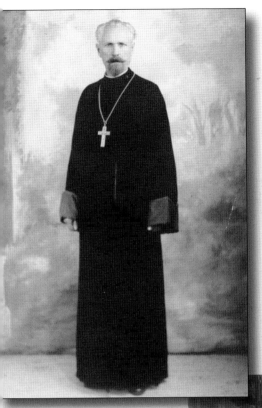

Alexis P. Gouguin

The Very Reverend Alexis P. Gouguin was born in the Kuban region of Russia. At age 20, he became a schoolteacher; at 25, he immigrated to the United States (Minneapolis, Minnesota) where he taught an Orthodox 'Church School' before his ordination to the priesthood in 1916 in Winnipeg, Canada. Assigned to various parishes in Canada and Minnesota, Father Gouguin spent 34 years as a parish priest and pastor in the Philadelphia region. Father Gouguin was known as a caring priest who would go out of his to make house calls, and his first parish in the city was Holy Virgin Church at Twenty-eighth Street and Snyder Avenue in South Philadelphia. He was later transferred to St. Nicholas Eastern Orthodox Church at Fifth and Brown Streets, where he remained for 21 years. Unlike Roman Catholicism, Orthodox Christianity came late to Philadelphia. It was not until 1897 that a group of immigrant Russian naval officers and sailors established St. Andrew's Brotherhood. This later led to the building (and consecration) of the first Orthodox cathedral, St. Andrew's, at Fifth and Front Streets. The cathedral was consecrated by Bishop Tikhon (later, St. Tikhon) in 1902. (Courtesy of Rev. Gregory Winsky.)

St. Andrew's Russian Orthodox Cathedral

Fr. Mark Shinn is the archpriest and pastor of Philadelphia's Saint Andrew's (Russian) Orthodox cathedral. Father Shinn converted to Orthodoxy as a teenager. Of Orthodox Church architecture (and sacred architecture in general), he has noted that the first worship communities during the American Colonial era, namely the Congregational churches (descendants of the Puritans), thought of the church building as having a dual purpose: it was both a meeting place as well as a place of prayer. The Congregational idea of a dual-purpose church building quickly filtered down into most Protestant denominations.

"Leafing through old Congregational handbooks and manuals," Father Shinn says, "it is clear that these churches were constructed as meeting and prayer houses. This becomes clear when you watch reruns of *Little House on the Prairie*, where the church and school house are one and the same thing. In the 19th century and earlier, traveling magistrates held court in these combination prayer/meeting houses. There was absolutely no sense of these meeting houses as sacred space dedicated solely to the worship of God. That has been the reality for American Protestant churches for generations. The idea of a sacred space devoted solely to the worship of God did not exist." (Both, courtesy of Jim Talone.)

Fr. Mark Shinn

In July of 1998, the *Philadelphia Inquirer* reported that Father Shinn, the 48-year-old pastor of St. Andrew's Russian Orthodox Church in the city's Northern Liberties section, had been carjacked about 10:00 p.m. as he returned from visiting a hospitalized parishioner. He was driven around for about 40 minutes by three abductors who threw a blanket over his head, pistol-whipped him, and, he said, "talked about where they were going to kill me and dump me."

The van finally stopped near Twenty-ninth Street and Adams Avenue in Camden, and Shinn was walked into a field and shot once in the back—just after one of the assailants said, "I guess God is going to forgive us for all we've done, huh Father?"

Shinn did not answer the question.

Two shots were fired, one hitting the priest near the shoulder blade and exiting the front of his body, before the assailants drove off in the van.

"I pretended to be dead." Shinn remembers. "I heard them pull away, and I waited two or three minutes—in case one of them was still there watching. Then I carefully turned my head and looked and got up." (Courtesy of Jim Talone.)

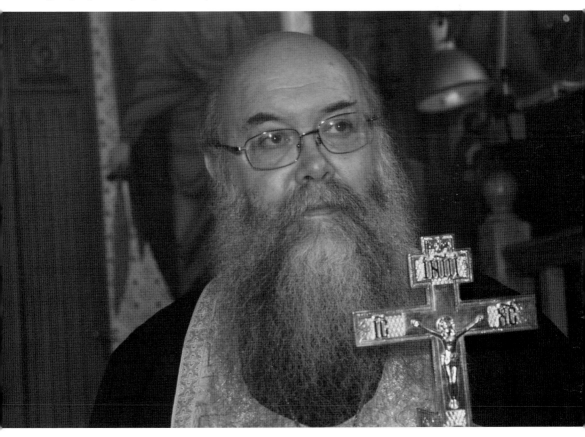

Fr. Gerald Carey

St. Paul's Church in South Philadelphia used to be the meeting place for Philadelphia's Traditional Latin Mass (TLM) community. Fr. Gerald Carey, the former pastor, would wear traditional fiddleback vestments and begin the prayers at the foot of the altar. The TLM was a 12:00 noon staple at St. Paul's parish for several years.

"The Traditional Latin Mass has had a slow comeback," Father Carey says. "But it's always been part of the heart of the Church, but I think that the Holy Father would like it to be even more so, maybe because of the ways in which the Ordinary Form of the Mass has been handled."

Years ago, when there was a large Catholic community in South Philadelphia, St. Paul's would offer eight Masses on a Sunday. The parish was about to eliminate the noon service when Father Carey brought in the TLM. At that point, people began flocking to the church from Center City and the suburbs. The news (and popularity) of the Mass also attracted former parishioners of St. Clement's Anglo Catholic in Center City and congregants from St. Jude's SSPX (Society of St. Pius X) chapel in Eddystone, Pennsylvania.

Although Father Carey thinks that the Latin Mass should have been brought back a long time ago, he is very grateful that the "Mass of the Ages" is finally making a serious comeback. "There are still Catholics who walk in here during the 12 Noon Mass and think that a UFO landed on them," he told me. "There are young Catholics in their 20s who have no idea that we used to receive communion kneeling at altar rails. Some don't even know what a Latin Mass is. They'll say, 'What's that?' Some will walk in off the street, see this Mass, and be in a state of shock. One person asked, 'Is this a private affair?'"

Father Carey says that when he distributes communion —there are no lay Eucharistic ministers in the Extraordinary Form or the Roman Rite—he sometimes sees people crying as they kneel at the altar rail. (Author's collection.)

Bishop Francis Patrick Kenrick

An evening of ghost storytelling at Philadelphia's St. Malachy's Church celebrates the life and legend of the city's third Catholic bishop, Francis Patrick Kenrick. Born in Dublin, Ireland, Kenrick was selected at age 18 to study in Rome. He was ordained in April 1821. After ordination, he served Catholics in Bardstown, Kentucky, until he was appointed coadjutor bishop of Philadelphia. At the time of his elevation to bishop in 1844, anti-Catholic sentiment raged in the city of Philadelphia. During the infamous anti-Catholic Know Nothing riots, Bishop Kenrick took the high road and advised Catholics not to fight back but to be charitable in the face of persecution. Kenrick had the same attitude during the city's cholera epidemic, when he helped Protestant and Catholic alike, despite his personal belief that the plague was God's punishment for the city's overindulgence in food and drink. During those terrible plague days, Kenrick would walk the streets with the Sisters of Charity and minister to the sick and dying. Pictured from left to right are Bob Toczek, Mal Whyte, Thom Nickels, Marita Krivda Poxon, and Dr. Bill Watson.

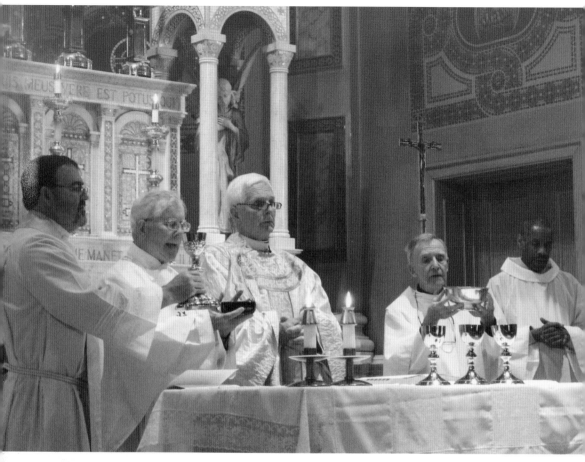

Rev. John P. McNamee

Rev. John P. McNamee, pastor emeritus of St. Malachy Church in North Philadelphia, was ordained a priest by John Cardinal O'Hara in 1959. Father McNamee, who has spent most of his priesthood serving the poor and disadvantaged, is credited with bringing Dorothy Day's Catholic Worker movement to Philadelphia. An award-winning poet, his books—*Clay Vessels* and *Endurance: The Rhythm of Faith*, have been popular spiritual bestsellers. His autobiography, *Diary of a City Priest*, won the Catholic Press Association Book Award and was made into a movie for television starring actor David Morse in 2001. An international speaker, Father McNamee received a doctor of humanities honorary degree from Villanova University in 2001. (Courtesy of St. Malachy Church.)

Sr. Evelyn Eynon

Founded by St. Clare (a friend of St. Francis of Assisi) in the 13th century, the Poor Clares that came to Philadelphia in 1918 were part of the so-called primitive order. Other branches of the Poor Clares include the strict observance Colettine, who practice mendicancy, perpetual fasts (Lent without end), live in strict enclosure, go barefoot and wear the traditional habit, and the Urbanists, whose rule was modified and made less austere by Pope Urban IV. There are also the Poor Clare Nuns of Perpetual Adoration (PCPA), a Pontifical Order of Cloistered Nuns, founded in Paris on December 8, 1854.

When the Poor Clare nuns came to Philadelphia's Girard Avenue in 1918, it was an area inhabited by wealthy Gilded Age industrialists like Peter A.B. Widener. Widener's Willis G. Hale's-designed home was a baroque mansion on the corner of Broad Street and Girard Avenue.

The Francisville area in the 1950s and 1960s was also home to the Carriage House offices of architect Vincent Kling and Lankenau Hospital. Lankenau was founded in 1860 as "the German Hospital of Pennsylvania" on North Philadelphia's Morris Street but was renamed when the United States entered World War I, a time when anti-German bias was particularly pronounced.

Sister Evelyn Eynon, a Poor Clare nun who began living at the Francisville monastery in 1955, remembers the move to a new monastery in Langhorne, Pennsylvania: "We knew that there was no way for us to take care of the needs

of the monastery. It needed new electrical fixings, it needed new plumbing. Even the fire escapes had to be redone; it was just a tremendous project. There was no way we could continue. The cheaper thing was to move, so that's what we did."

The pre-Vatican II era (1955) was a healthy time for the Catholic Church in America. The Poor Clare monastery at that time housed between 42 and 44 sisters, a figure that would drop after Vatican II. By 1977, the year the Poor Clares moved from Girard Avenue to Langhorne, there were 24 to 26 nuns.

The 1970s was a sometimes (unhappy) revolutionary period in American Catholicism. This is the decade that—architecturally speaking—wreaked havoc on traditional Catholic Church architecture, when high altars were removed, statues and altar rails eliminated, and when new church design seemed to ignore St. Thomas Aquinas's assertion that the worshipper's mind is elevated to contemplation through material objects. Pictured here is Sister Mary Patrick. (Courtesy of Poor Clares.)

Todd Hemperly

Todd Hemperly, who was born with a major physical disability, says he knows what people think when they see him for the first time: "They think I'm severely disabled, that I don't have arms, and that I'm confined to a wheelchair, and then they wonder, 'What kind of life is that?'"

Most people want to know why Todd doesn't have arms, and when he tells them that's he's from Middletown, Pennsylvania, the area around Three Mile Island, they think of the nuclear accident there in 1979 and assume this is what caused his disability. "But I was born before the nuclear accident at Three Mile Island," Todd says.

Other people him if his mother took thalidomide, the drug that was given to women by doctors in the early 1960s. "My mother never took ghalidomide; at least that's what she always told me. I am the way I am because of genetic factors. As far as I know, nobody else in my family was born this way.

"This way," of course, refers to the fact that, for Todd, his feet are his hands. "I use my feet to type, eat, point, open mail, pet my cat Leo, and work the remote control for my TV," he adds.

In traveling about the city in his motorized wheelchair, Todd says he is amazed at how many people think he doesn't work but sits home and collects disability checks. He's says he's proud to tell them that he's had the same job for over 22 years.

"People stare at me in public but not as much as they used to. I attribute this to the increased awareness of disabled people in society," he says.

He feels very good about this change, though he admits that he used to be bothered by the stares of little children. "Children are naturally curious, and they want to know why something is the way it is, so over time I began to comfortably answer their questions about my disability. But then I found that it was the parents who would draw the children back and tell them, "Don't ask him that. Don't be rude.

But it's not rude, he insists.

"I will tell a parent, "Let the kid ask, it is really okay. They should know. How else are they going to know? Let them hear it from me."

Todd says that a lot of his life has been spent on the road...not as a traveler to exotic places, but as a wheelchair driver. "Driving through the streets of the city is not always easy for me," he says. "I have had many near misses with cars, so many in fact that I had to figure out how to get to and from my place of work from my Center City apartment. So I devised a way to get to work via the subway concourse and as a result I more than cut in half the number of car-wheelchair near misses."

Todd's first wheelchair-car near miss was in University City near the Penn campus. He was headed out to the school cafeteria to get some food to bring back to his apartment, when a woman in a car clipped his wheelchair. She got out of the car and began to cry. She couldn't apologize enough, but Todd says that his mind was only on the food, so he brushed the incident off with a "It's okay Miss, it is okay." He was finally able to get dinner.

"Another time in Center City a male driver almost hit me," Todd said. "He was so apologetic he handed me a twenty dollar bill. Now, I really don't like it when people just hand me money, but in this case I took it. But there have been times when people have just come up to me and handed me money, as if in their minds a disabled person in a wheelchair equals a homeless person in desperate straits. I'm proud to say that I have never accepted money under these circumstances."

Todd says that even though he is disabled, his parents wouldn't be happy if he quit his job and asked them if he could move back home. He says he considers an action like that falling victim to loser status: a man in his forties living at home with his parents. "It's certainly not something my mother would respect, and since I am like my mother, I wouldn't respect myself either. (Both, courtesy of Todd Hemperly.)

Pres. Henry B. Eyring

Pres. Henry B. Eyring, first counselor in the First Presidency of the Mormon Church, broke ground for the first Mormon Temple in Philadelphia on September 17, 2011. Baptized in Philadelphia as an eight-year-old, Eyring grew up in Princeton, New Jersey, was educated in Utah and Harvard, and met his wife-to-be, Emma, in Harmony, Pennsylvania, the seat of much Mormon history. At the Philadelphia ground-breaking ceremony (where Eyring's presence was billed as his "return to Philadelphia") the first counselor said that there are currently "135 operating temples and more than 20 announced or under construction in 27 countries and on every continent except Antarctica." He told the assembled crowd, which included Philadelphia mayor Michael Nutter, that "no building is more sacred than a dedicated temple of God. Only in them can the bonds of family in mortality be extended for eternity."

The proposed Mormon temple at 1739 Vine Street near the Philadelphia Parkway promises to clear the way for future Mormons in Center City. The design is one of many currently in use throughout the Mormon world. The Philadelphia temple will have two spires, one hosting an image of the Angel Moroni, the angel who, according to Mormon belief, appeared to Mormon founder Joseph Smith in Palmyra, New York, sometime after Smith asked God which church he should join. The Philadelphia temple spires will reach more than 200 feet in height, providing an impressive point of reference in a skyline filled with crosses and steeples. The 68,000-square-foot building will house a visitors' center, a family-history center, a financial-service office for LDS communicants, and an employment-services office. Renderings of the proposed structure show an eclectic mix of Greek Classicism and Federalist 18th- and 19th-century styles, the antithesis of the work of current architectural legends Frank Gehry and Zaha Hadid.

The Philadelphia design is one of the more basic temple templates, chosen from a wide range of styles in use throughout the world. The two-spire temple is, in fact, one of the more recognizable Mormon temple styles and will blend harmoniously with the Parkway's Neoclassical structures.

The signature capstone, of course, will be the towering, gilded fiberglass Angel Morni, trumpet in hand, which promises to compete with the cross atop the Catholic Basilica of SS. Peter and Paul. (Courtesy of the author.)

Tomas Dura

Tomas Dura, Philadelphia actor, choreographer, and flamenco dance performer, has appeared in film, radio, and television. For almost a decade, he studied with the great Jose Greco, later becoming Greco's assistant. In 2007, he performed solo his own choreographed version of a Spanish *Swan Lake* with the Philadelphia Orchestra at the Kimmel Center. He is currently the director and lead male dancer of Fiesta Flamenco Dancers. (Both, courtesy of Tomas Dura.)

INTERIOR OF THE ASSUMPTION CHURCH

Saint Katherine Drexel

St. Katherine Drexel was born in 1858 into the prominent Drexel family. Growing up, her parents taught her that wealth should be shared with the less fortunate. From an early age, she discovered that she had a passion for the material and spiritual welfare of black and native peoples. She founded the Sisters of the Blessed Sacrament for black and native women, and during the course of her life spent her $20 million fortune on the needs of the underprivileged. She established missions in New Mexico and founded Xavier University in New Orleans in 1915. She is known as Philadelphia's most beloved Catholic saint. St. Katharine Drexel was baptized in the Church of the Assumption (pictured), on Spring Garden Street.

INDEX

LEGENDARY LOCALS

AN IMPRINT OF ARCADIA PUBLISHING

Find more books like this at
www.legendarylocals.com

Discover more local and regional history books at
www.arcadiapublishing.com